DEC 01 1998

Brush Mind

Text, Art, and Design by
Kazuaki Tanahashi

Parallax Press
Berkeley, California

ENTERED DEC 1 7 1990

759.952 T161b

Tanahashi, Kazuaki, 1933-

Brush mind

Parallax Press
P.O. Box 7355
Berkeley, California 94707

Text, art, and design
©1990, by Kazuaki Tanahashi

Cover photo of Kazuaki Tanahashi
©1987, by Rob Lee

All rights reserved.

Printed in the United States of America.

Permission to print the following materials is gratefully acknowledged:
Kabir's poem—*The Bijak of Kabir*. Trans. Linda Hess and Shukdev
Singh. San Francisco: North Point Press, 1983. Rumi's poem— *Unseen
Rain: Quatrains of Rumi*. Trans. John Moyne and Coleman Barks.
Rutland, Vermont: Threshold Books, 1986. Dogen's lines—*Moon in a
Dewdrop: Writings of Zen Master Dogen*. Ed. Kazuaki Tanahashi. San
Francisco: North Point Press, 1985.

Library of Congress Cataloging-in-Publication Data

Tanahashi, Kazuaki
 Brush Mind
 Collection of statements on art, creativity, and life; with one-stroke brush
 paintings
 1. art, philosophy, Zen, humor
 I. Tanahashi, Kazuaki 1933 II. Title
BQ 1990
ISBN 0-938077-29-5

To my dear Ko

Do you still want to
pop bubbles
with me?

Preface and Acknowledgments

The brush was invented in China as a writing tool over two thousand years ago. It may be that our writing tools, brushes or pens, have not only formulated styles of writing but have also influenced broader visions—the way we see and structure the world—more than we normally realize. The mark of the writing instrument may appear in the fields of music, architecture, medicine, law, and politics. This book includes some of my observations on the tools and goals of people who create art in East and West.

It seems that throughout my artistic life I have been stumbling along between these two traditions: In 1956 in Japan I started studying Chinese/Japanese calligraphy as well as oil painting with private teachers. Gradually my painting became abstract, synthesizing the aesthetics of East Asian calligraphy and the direction of contemporary Western Expressionists. Jackson Pollock and Franz Kline were two of the artists I most admired.

Zen Buddhist thinking, particularly the irony of having to give up in order to arrive at something, attracted me. According to Buddhist teaching, we have no permanent self, no lasting possession. It is therefore essential to develop a sense of detachment from all possessions, including one's views and habits. Such an understanding is central to my art; my life as an artist has been a continuous challenge to give up. I abandoned concrete forms, then colors, shades, nuance, refinement, and the attempt to please, as well as the use of a seal or signature.

I first visited North America and had exhibitions in 1964-65, when I was fortunate enough to receive some recognition and to have opportunities to teach at universities. Upon returning to Japan, however, I stopped exhibiting my art, as I felt striving towards further recognition might ruin my integrity as an artist. During the fifteen-year period in which I did not exhibit, I wrote books on Japanese Buddhist art and literature.

I returned to the United States in 1977 to work as a scholar-in-residence at the San Francisco Zen Center. It was exciting to watch what happened when the traditional Zen teaching from Asia arrived in what may have been the most experimental society in history.

In 1980 in San Francisco a friend gave me some beautiful cotton paper he had made. Naturally I started painting again, with pitch-dark ink. One day, without any

definite intention, I drew a straight horizontal line across the center of a piece of paper. At the moment the brush would have moved to another stroke, something stopped me from adding anything. I had a feeling that what I wanted to express was all there—in the single line and in the space above and below. So I put down the brush. Soon a number of one-stroke paintings rushed to me. In my second phase of work as a painter, I started on the laziest side of the guild. As a calligrapher, I seemed to be stuck at stroke one.

Painting in this form was merely a joke to some of my friends. I also enjoyed making fun of such art and recorded a series of thoughts, which I called "funny lines." Linda Hess was kind enough to help polish the English. Soon she became my life-time partner—a serious part of my lines.

Karl Ray, a wonderful editor and close friend, suggested in San Francisco in 1984 that I create a book of short statements with reproductions of some of my paintings. I proposed the title "Brush Mind" and decided that all the paintings in the book should be called "Mind." Since mind is unpaintable, I wanted to paint it.

When my family and I were living in New Hampshire in 1985, from dozens of existing one-stroke pieces done on large sheets of watercolor paper or illustration board, I cropped sixty paintings down to 7-1/2" x 9-1/2". Karl wanted to publish the book in the press he was intending to establish. Unfortunately he became sick and decided to return the manuscript to me. The last time we spoke before his death, he said, "I have faith in your book. I still want to help you in whatever way I can." I am filled with love and gratitude when I think of him.

Arnold Kotler, the founder of Parallax Press, is one of the people with whom I translated *Moon in a Dewdrop: Writings of Zen Master Dogen*. During a conversation in Berkeley in 1988, I told him about my manuscript, and he immediately accepted it sight unseen. I admire his vision and appreciate his care at every stage of the book production. My appreciation also goes to Dana Britton whose hard work at the press has help me enormously.

Thanks to Ward Fleming for the paper, as well as for letting me work in his studio in 1980, and to Mel Van Dusen for fishing a painting of mine out of the garbage—an incident described in the text.

Portions of this book were published in the following periodicals: *Friends of Calligraphy Newsletter* (1982), *Whole Earth Review* (Summer 1988), *Calligraphy Review* (Fall 1989), *Current* (1988-89 issues) and *Fish Drum* (Issue 5, 1989). I would like to thank the staffs of these magazines as well as the editors, Georgianna

Greenwood, Kevin Kelly, Karyn Gilman, Simon Jeremiah, and Robert Sycamore for their support. Georgianna gave me valuable suggestions which have affected the final form of the book. The idea of the cover photograph was originally conceived by Karyn, and the spectacular shot by Rob Lee was first published on the cover of *Calligraphy Review*.

Paul Maurer, who lives in Pennsylvania, and Keith Lebenzon, in Oregon, are two people who make brushes in very imaginative ways with hair of unusual animals. The poems included in this book owe much to the experiences of working with them. My father Nobumoto at times sent me brushes made in East Asia, the size of which kept increasing until 1987 when I made brushes larger than either of us had ever seen.

I feel fortunate to have so many friends in North America and Europe who practice Western calligraphy. I owe thanks to Tensho David Schneider and Virginia LeRoux for introducing me to the wonderful community of calligraphic artists. Part of my pleasure in teaching brushwork comes from working with director Liz Kenner and co-director Linda Richardson of the California School of Japanese Arts, Santa Rosa, and I thank them for their support on the book project. Conversations with Roger Keyes, Dian Woodner, and Arie Trum have always stimulated my thinking. Norman Fischer helped me by commenting on the manuscript. I bow back to Peter Levitt's bowing which was sent to me along with his imaginative comments. John Prestianni's technical advice on design is greatly appreciated.

Hearing about the book in the final stage, Bob Brocob, my friend and co-teacher in the workshop "Form and Space in Japanese Design and Art," offered to help. His enthusiasm brought some of our common friends together to finance the project. My heartfelt thanks to Nancy Mayer, Jerry Prohaska, Kent Sugai, Carole and Don Watanabe, and Bob himself for enabling the publisher and myself to work with so much ease and enjoyment.

Kazuaki Tanahashi
Berkeley, California
April 1990

Contents

Preface and Acknowledgments v

Line 1

Counterpoints 11

One Stroke 21

Mind 31

Unfamiliar Quotations 39

Paradigms 49

Breath 59

Space 71

Mindfulness 81

Brush Vision 91

Immediacy 103

Serious Questions 113

Reminders to Myself 123

Aesthetics of Laziness 137

List of Illustrations 148

Line

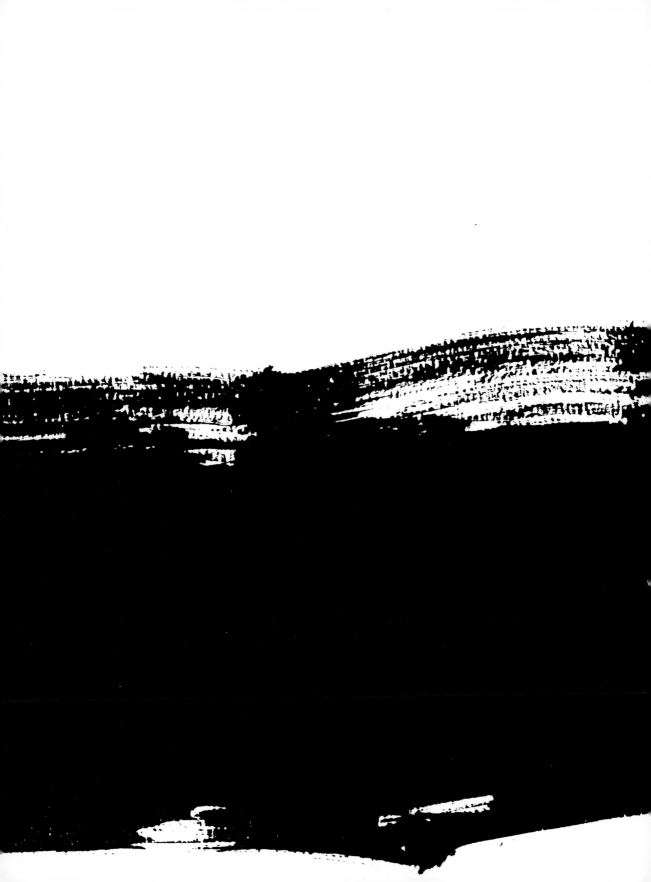

A line is amazing. A person's hand is the person. If you ask ten people to draw a line, how different each will be. Someone's straight line can be very crooked. Another person's line may not look straight, but it is very straight inside.

You can't hide anything in a line. You are there whatever line you draw. And you will stay there, even when you go somewhere else. If your personality is interesting enough, the line will be interesting. To do this, you have to be fearless.

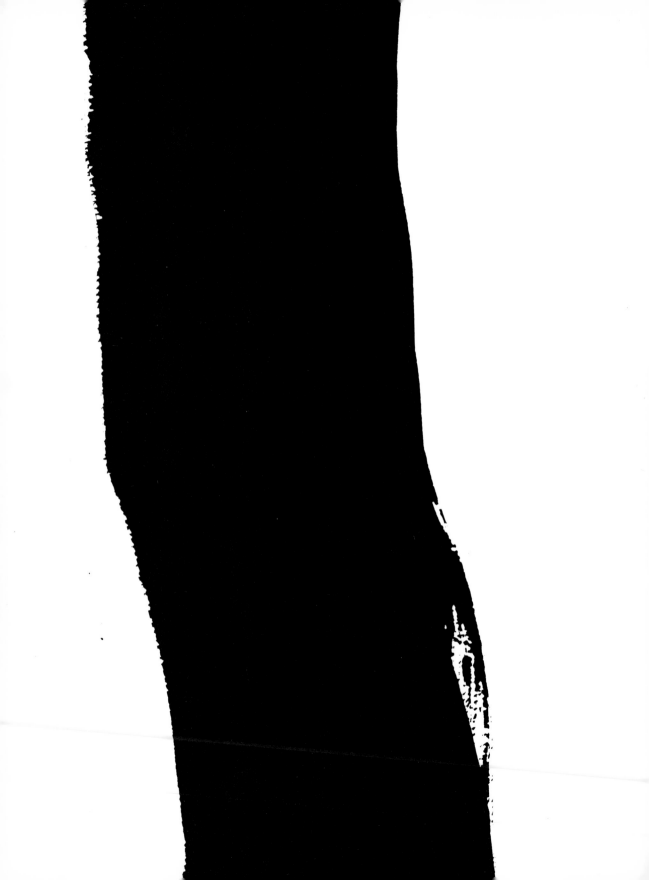

The quality of the line is what matters most—how deep, strong, or honest it is. It doesn't matter how good or unusual it looks.

Usually a line is serious—part of a square. This makes funny lines valuable.

A single line has a sense of cleanness. Dirtiness comes from mess, which is things getting together in a confused way. In one line nothing gets together, nothing is scattered.

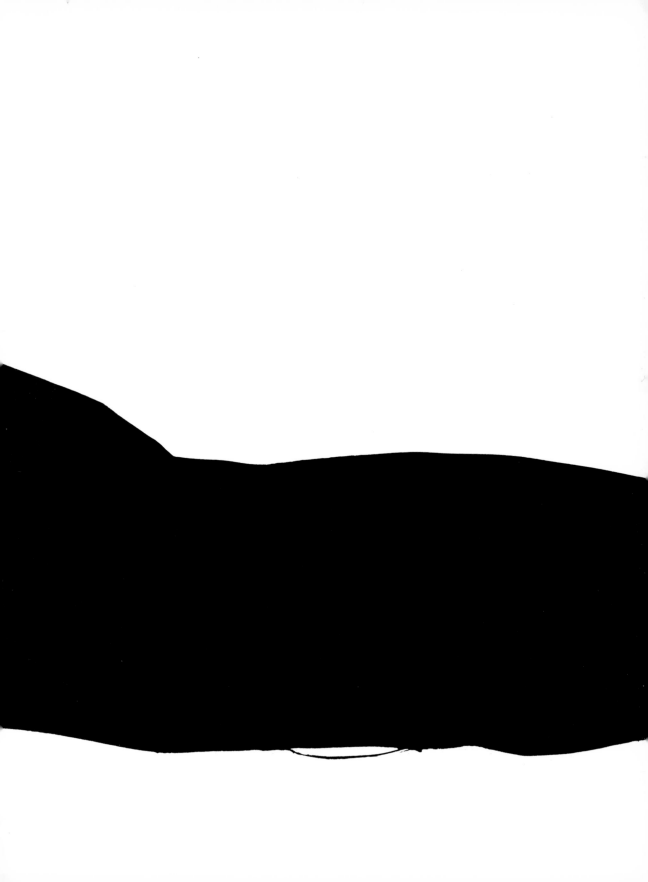

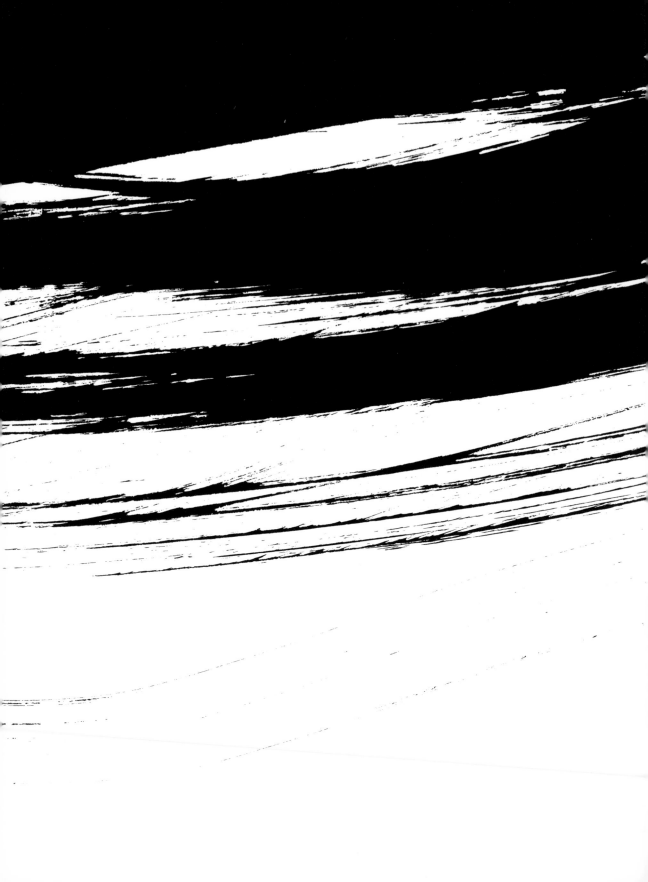

Let the thread continue to appear and disappear.

Every line we draw carries our wish for our children and their children.

Counterpoints

In the European tradition, masterpieces are often associated with struggle, suffering, and tragedy. In East Asia, creative people are supposed to be totally relaxed.

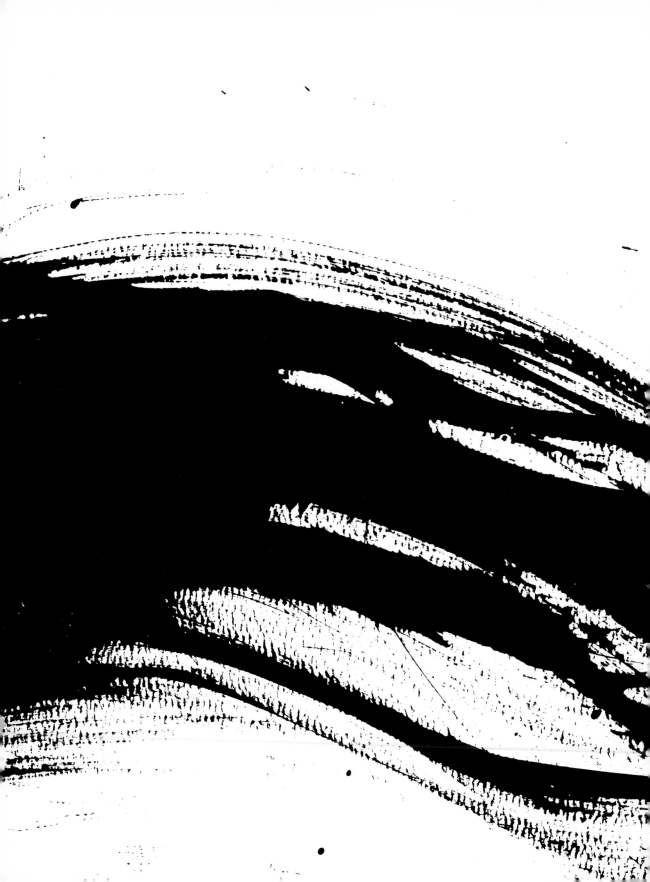

When you set up an easel in a museum and copy a Western painting, you try to get the composition exactly right, as well as shapes, colors, and texture. You want your product to be as close as possible to the original. When you copy an Oriental piece of art, you attempt to copy the process—the posture, the way of holding the brush, the order of strokes, the way of putting pressure on paper, the brush moving in air, the breathing, feeling, and thinking.

East Asian calligraphy requires you first to assume and then to know that some artists, say, of fourth-century China, had a much deeper sense of space and lines than we do. You spend years trying to capture the spirit of their work as people have tried to do for centuries.

Profundity and uniqueness: undeniable qualities of outstanding art. Profundity comes largely from discipline—learning techniques, copying ancient works, repeating the same things over and over. Uniqueness comes from freedom, which means to keep on learning from ourselves, discarding things we have learned from others. Here, classical pieces are not the ultimate goal; they are guideposts, sources of inspiration.

Where there is emphasis on profundity, there is tolerance for boredom. Contemporary art emphasizes uniqueness and tolerates weirdness.

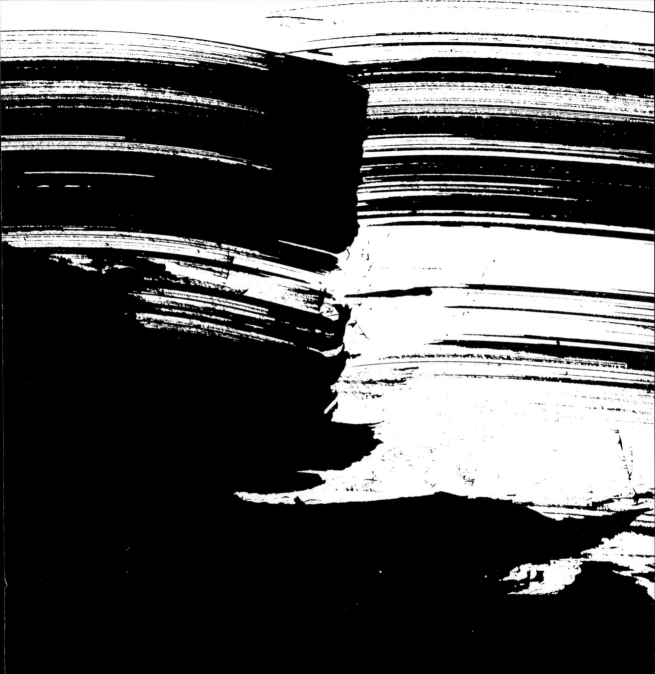

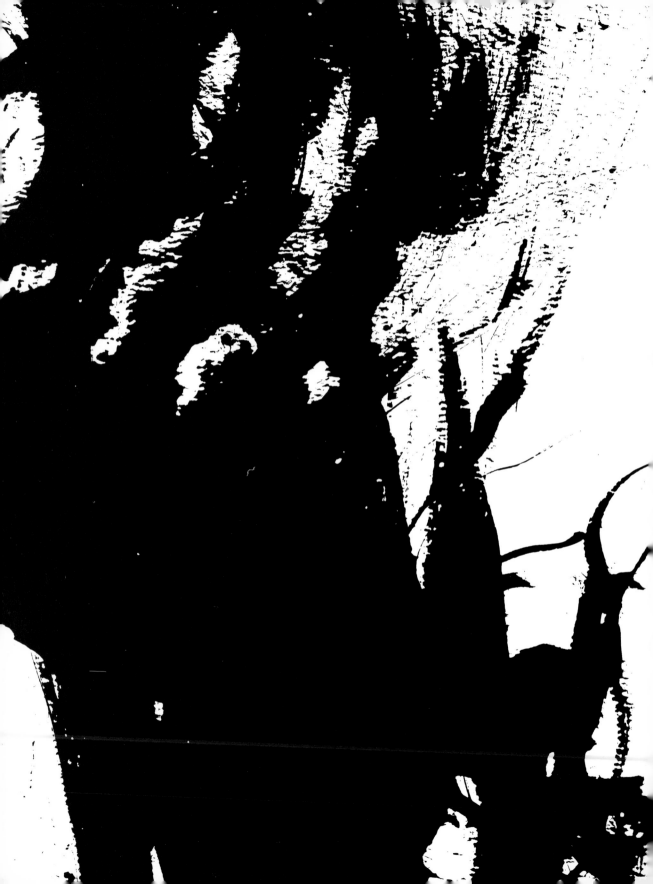

Masterpieces in the past lie on the edge of working and not working.
Masterpieces nowadays lie in the midst of not working.

One Stroke

One-stroke painting: a single line, straight or curved, painted in one breath.

To paint with just one brush stroke may sound like having a party by yourself. But if you can create a painting with one stroke, why do you need more?

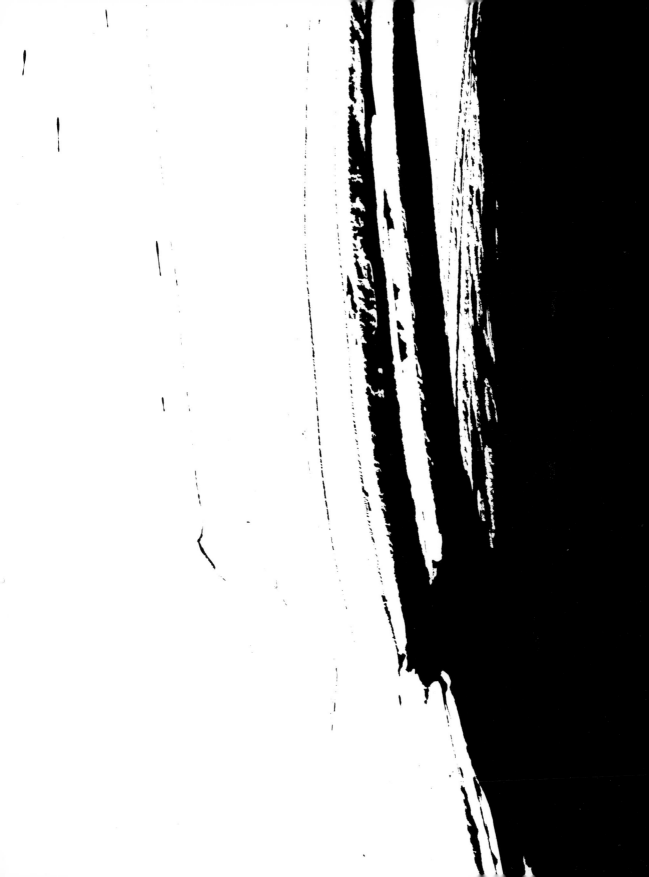

If you are a one-line artist, you can write a one-line poem, do a one-line dance, or file a one-line tax form.

In a one-stroke painting there is not much scope for composition. You just draw a line somewhere on a piece of paper. Still there are vast possibilities of what might occur, depending on the wetness or dryness of the brush, and the puddles, drips, and splashes of the ink.

Usually I have some kind of plan: Today I will draw a vertical line which is dry. Today I will try a dot. Or splashing a line from a bowl of ink. And when the forms come, I say, "Oh, isn't this nice? I can't believe that I have done it. It's too good for me. Somehow it's there." So it makes you feel light. You don't know what is going to happen—like flying.

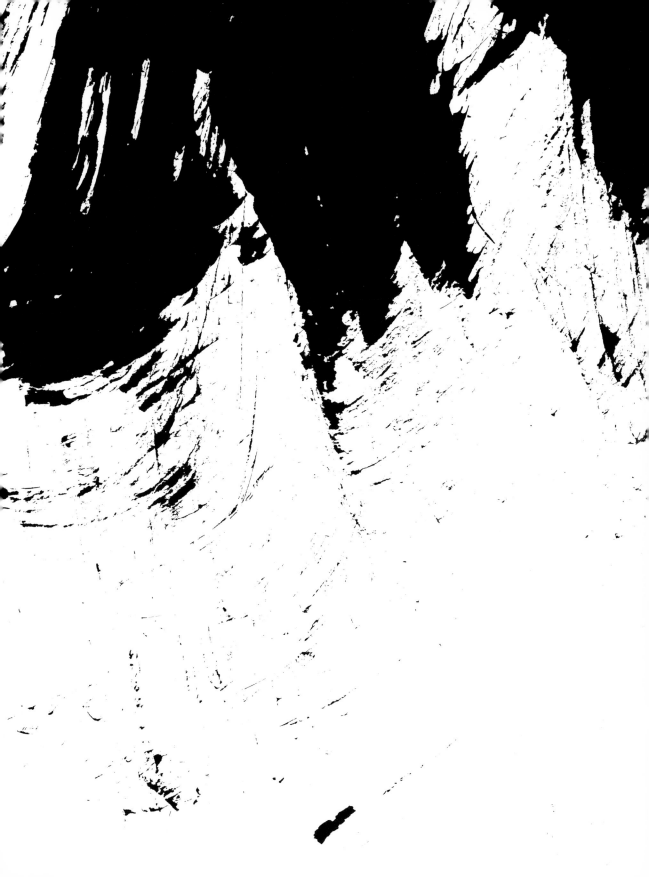

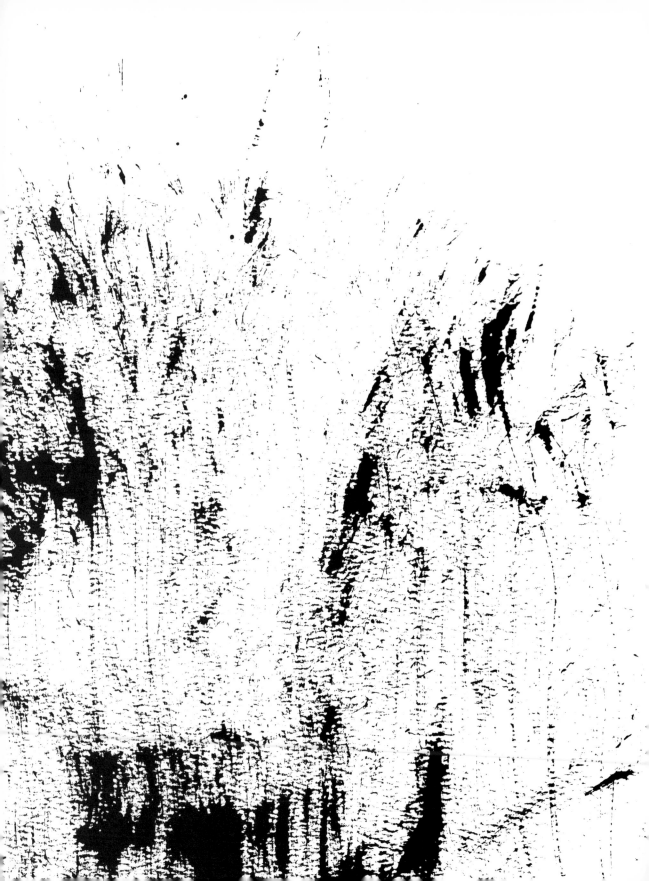

One-stroke painting leaves little room for thinking; the moment it's started, it's already done.

Because one-stroke painting doesn't take much time, you can paint in your friend's studio. So you can have a friend instead of a studio.

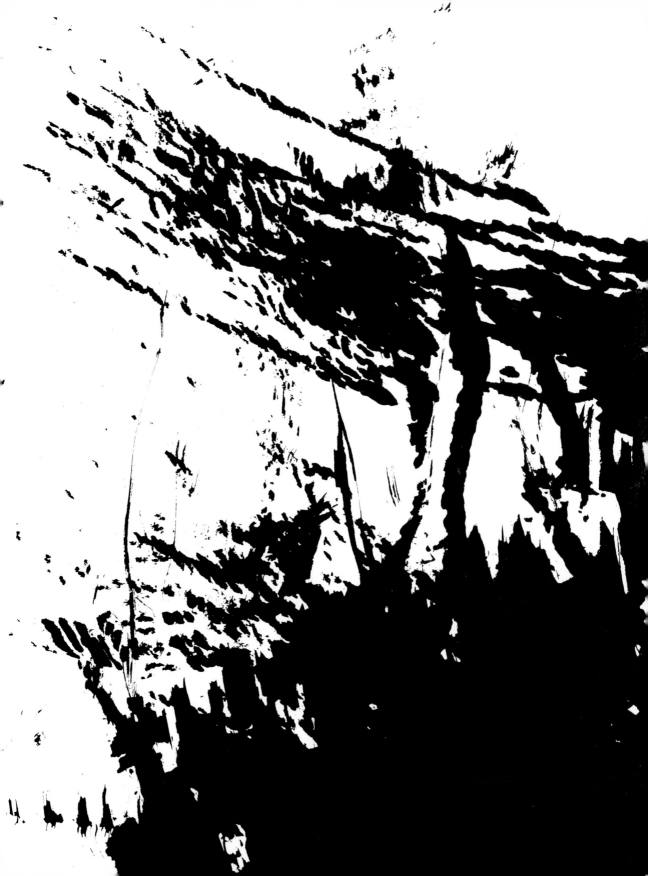

Mind

Mind is formless. It's just that there are innumerable forms in it.

Mind flows. It is never the same twice. Many things happen at once, contradictory and unrelated movements, yet it has direction and identity.

Bubbles of thought and gushes of passion rise here and there in mind. Many seem insignificant, but no one knows what will swell and become mainstreams.

Perspectives don't work on mind. Mind is here, now, too close for perspectives.

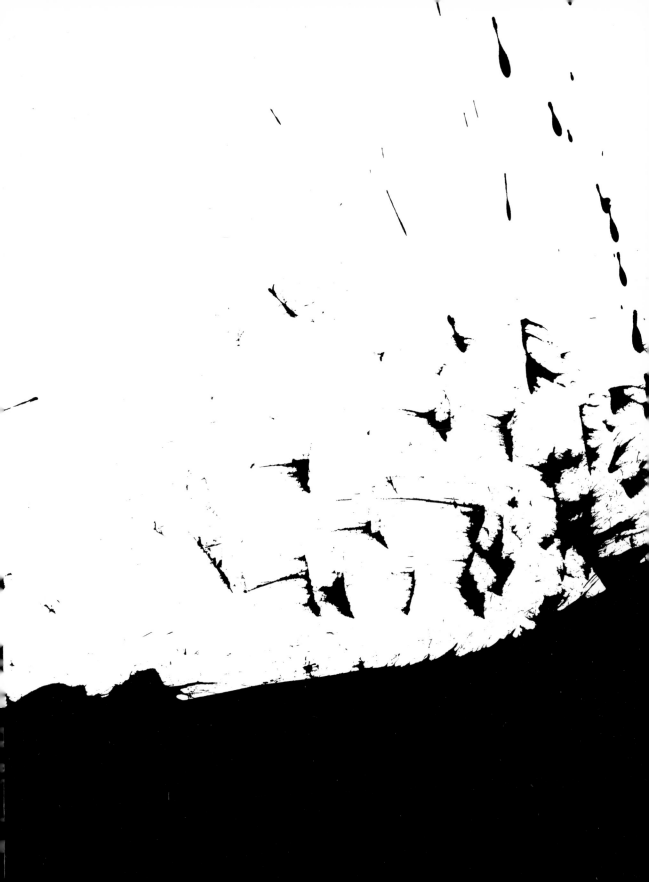

The mind, greedy for its own juice,
splashes in sensual waves.
Mind drives, body rides—
thus everything runs away.

Kabir

Joyful for no reason,
I want to see beyond this existence.
You open your lips, laughing.
I think of a design for that opening.

Rumi

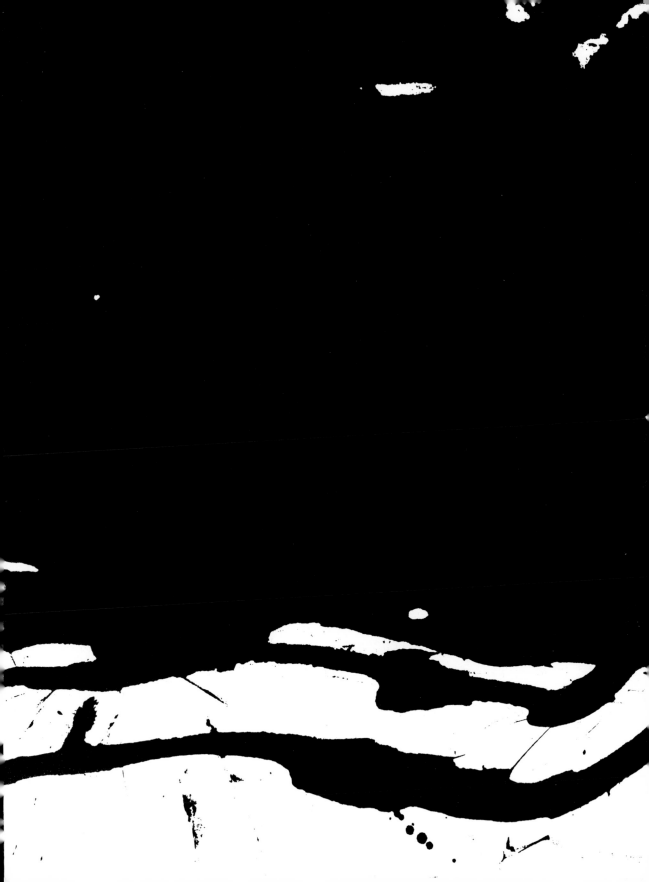

"Mind" and "heart" are represented by the same ideogram in East Asia, though pronounced differently in various countries—for example, "xin" in Chinese,"shin" and "kokoro" in Japanese.

Mind fights over pennies, love, territories. Mind returns to the origin of matter, goes beyond the boundaries of the galaxy.

Global heart, instead of individual mind, as the basis for shared vision and action.

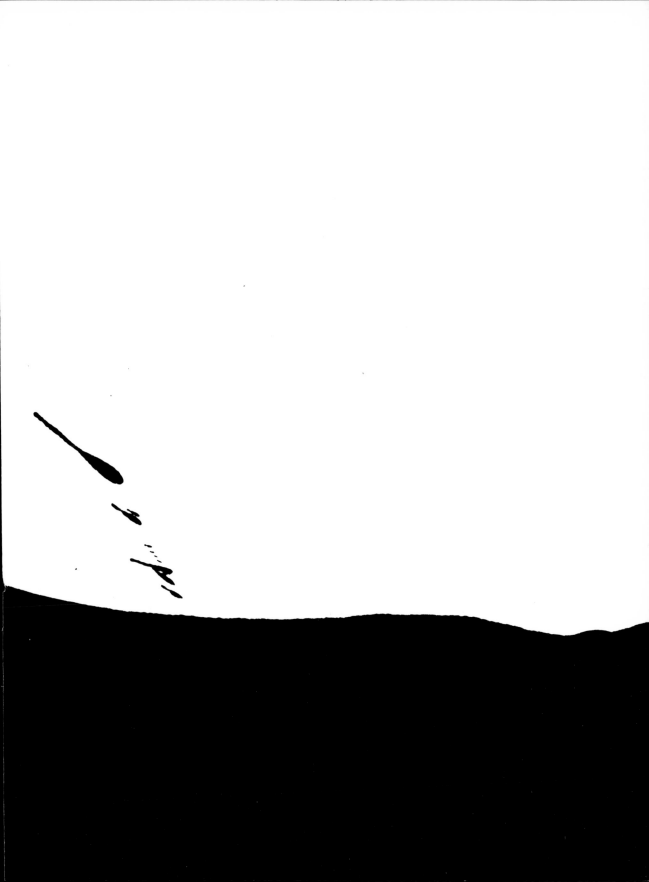

Unfamiliar Quotations

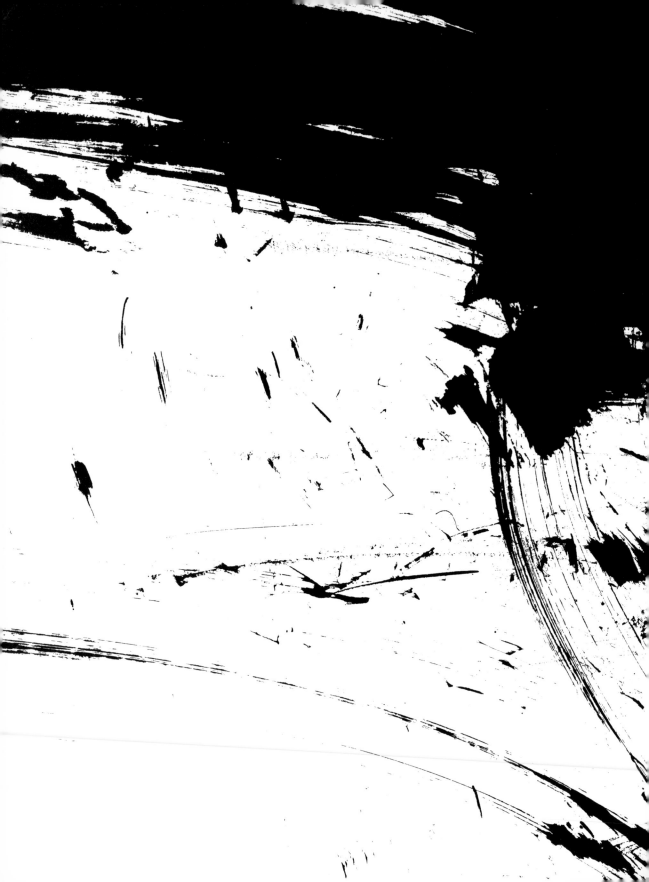

A friend of mine picked up a painting I had thrown into the garbage. He said, "What's the problem with this piece?" I said, "No problem." "Then why did you throw it away?" I said, "A painting has to have a great problem. If it has a minor problem or no problem, it's garbage."

The guest manager of the Zen monastery in Tassajara, California, called me up one day: "We just noticed that the painting of a circle you gave us has a title written on the back. It says, 'Square.' Did you do it on purpose, or was it a mistake?" "Gee, I don't remember," I replied. "But it sounds like an awfully good title. Please keep it."

The woodworker I was talking to about the brushes I had designed said, "Bamboo handles may look better." "I am an artist," I said. "Why should I care about looks?"

Almost thirty years ago in Japan, when I was a beginner as an artist (I still am), I was having tea with an old Zen Buddhist teacher and a well-established sculptor. The sculptor said, "I am in a slump. I cannot create anymore. What can I do?" The old man replied, "It seems that your problem is that you are a sculptor. Why don't you quit? If you stop being a sculptor, you have a chance to become a real sculptor." "Roshi," I said to the Zen teacher, "don't you think it's time for you to stop being a Zen master so you can be a real Zen master?" "You've caught me, young man," he said, "but don't you know that I quit a long time ago? Ha, ha, ha, ha!" "Man," I said, "You've passed." Soon the old man and I became partners and started translating Zen texts from medieval Japanese into modern Japanese.

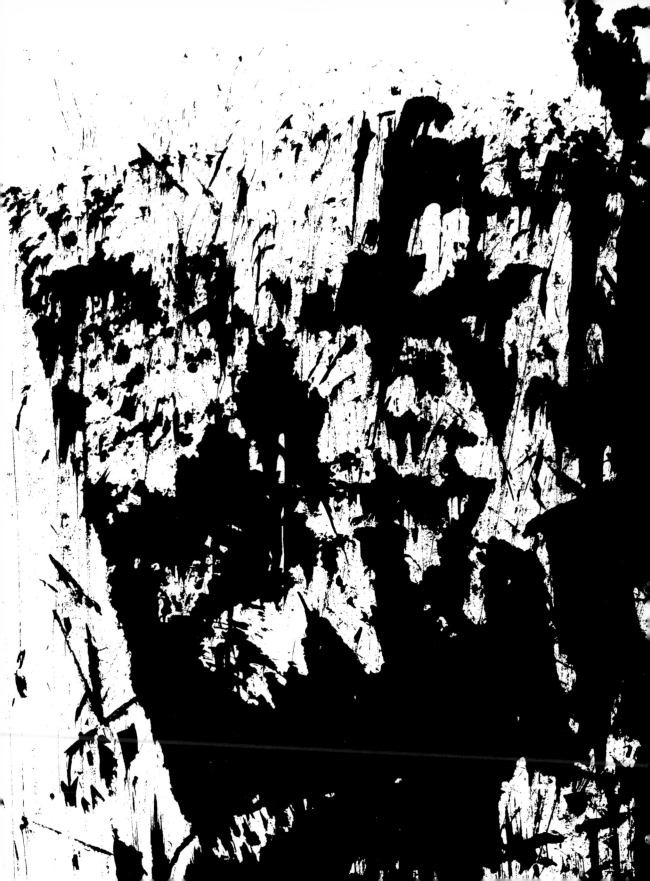

I said to my eight-year-old daughter, "Let's make a Christmas tree." "Out of what?" she said, "We don't have a tree." "Out of imagination. Don't you think it's better than using a cut tree?" "You mean you want to use imagination for supplies? But imagination is not the same as scissors, paper, or glue!" Yet the Christmas tree we made was rather magnificent.

An art director in New York said, "Kaz, I have a good idea for your one-stroke painting. You could get a whole year's work in a few minutes." "That sounds interesting. What is it?" "You rent an automatic car-wash place and run a long strip of paper through it. Instead of spraying water, you spray ink." "Do you think I should wax the paintings?"

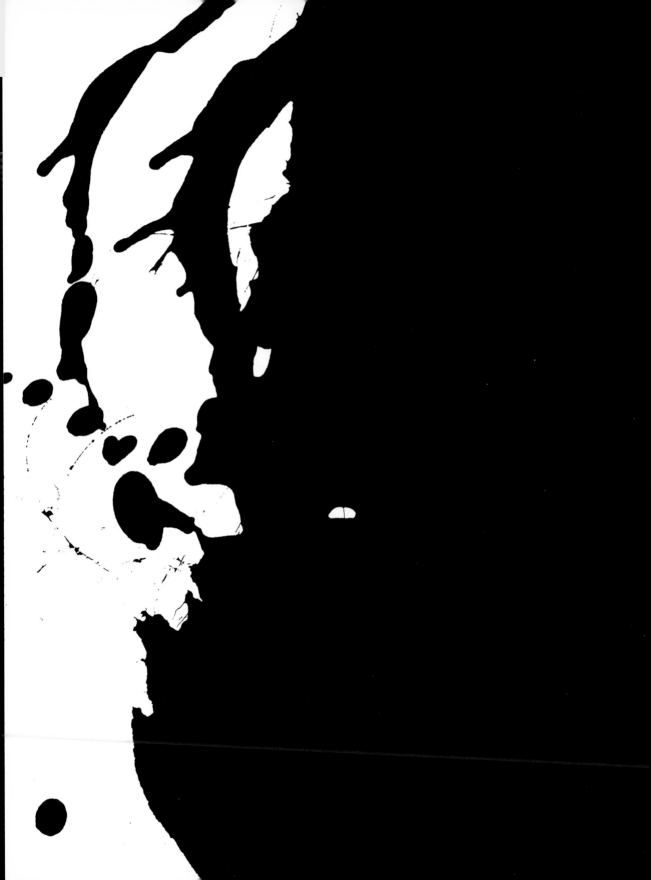

I once shipped a piece of my brushwork to Santa Clara, California, for a calligraphy conference. When I arrived a few weeks later, the person in charge of the Faculty Exhibit said, "One of the paintings you sent us wasn't framed. So we framed it for you. It's on exhibit now." "That's funny. I only sent you one piece." Then I realized that they had framed the paper board with brush marks on it, which I had used for packing. So I said, "I guess this mistake reveals the quality of my art. There's no way to tell the packing from the packed." Sure enough what was sold at the exhibition was the packing instead of the packed.

Paradigms

A bamboo brush is an extremely inefficient tool. It takes years to be able to draw a line the way you want to. It may be compared to a bamboo flute, the *shakuhachi*. To be able to make one note right on the *shakuhachi* takes a long time. But once you get it, the sound is so profound that even one note is overwhelming.

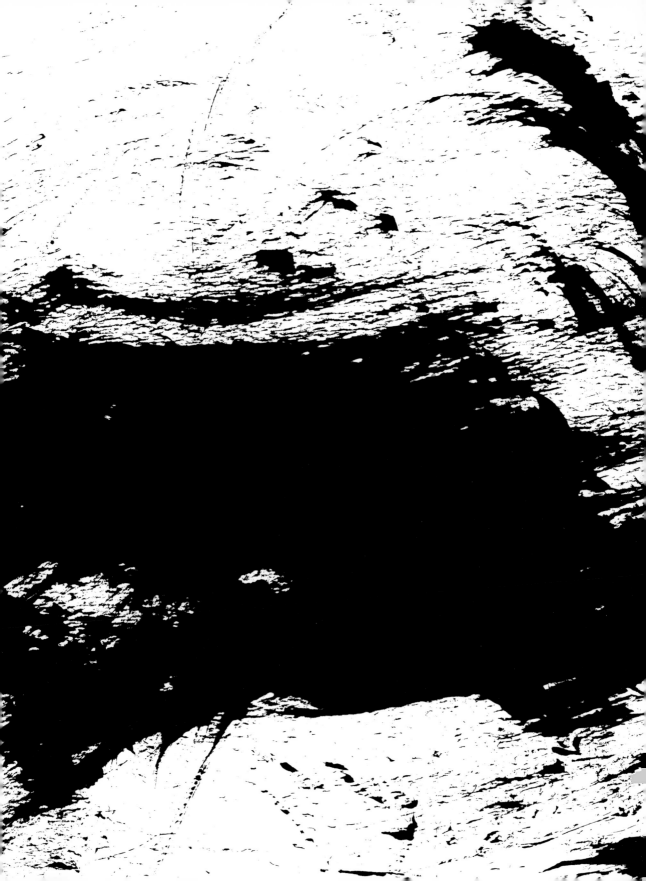

In brushwork of the East Asian tradition no one can make exactly the same stroke twice, as the bristle of a brush is made of many soft and long strands of hair, and has a life of its own. Every stroke is unique.

This brush is not suited to form precise geometric shapes such as straight lines, squares, circles, or arches. Rather, it has been developed to form organic shapes. When a line is alive, you always feel the breath of the artist as well as the breath of the brush.

One merit of the bamboo brush is its flexibility. Its bristle is pointed when it is wet and straightened, but with a push it can form a wide line, and then it can quickly go back to a fine point.

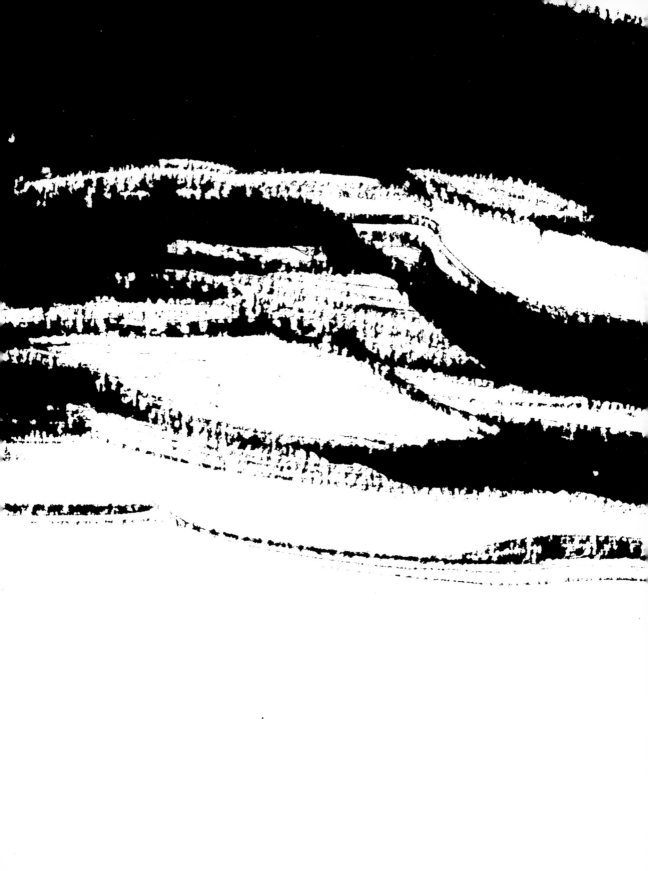

You are not expected to add ink or re-straighten the bristle until you finish the character you are writing. That means you often have to continue working with a brush whose hairs have come apart. A brush in this condition often creates broken or torn-apart lines. But soon you get used to working with a broken bristle. In fact, one of my favorite brushes is one that I used for years to scrub ink stones with. Its bristle is worn out and quite coarse. The worse a brush may seem, the better it may work.

In the Oriental calligraphic tradition, you are not supposed to touch up or white out a trace of your brush. Every brush stroke must be decisive; there is no going back. It's just like life.

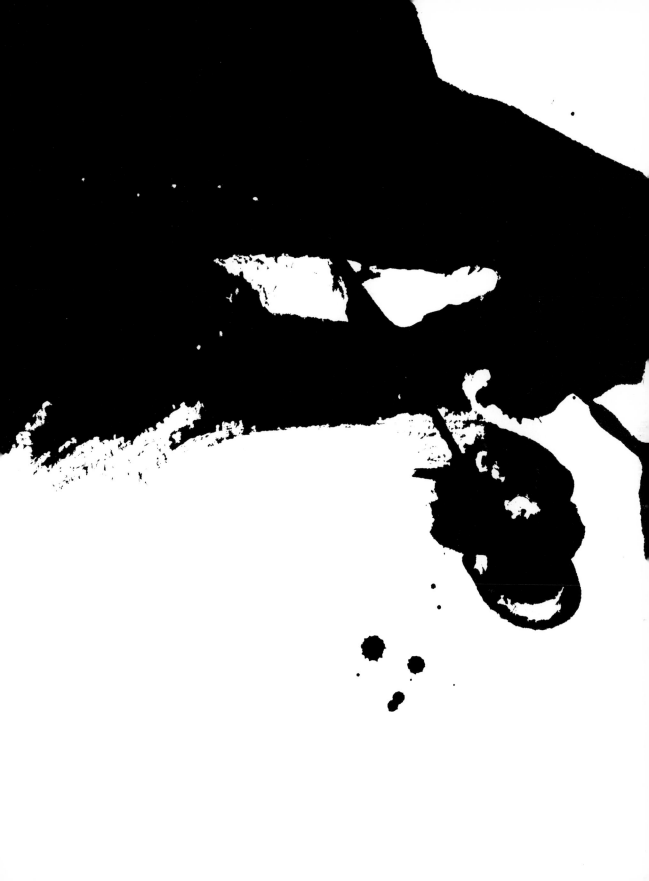

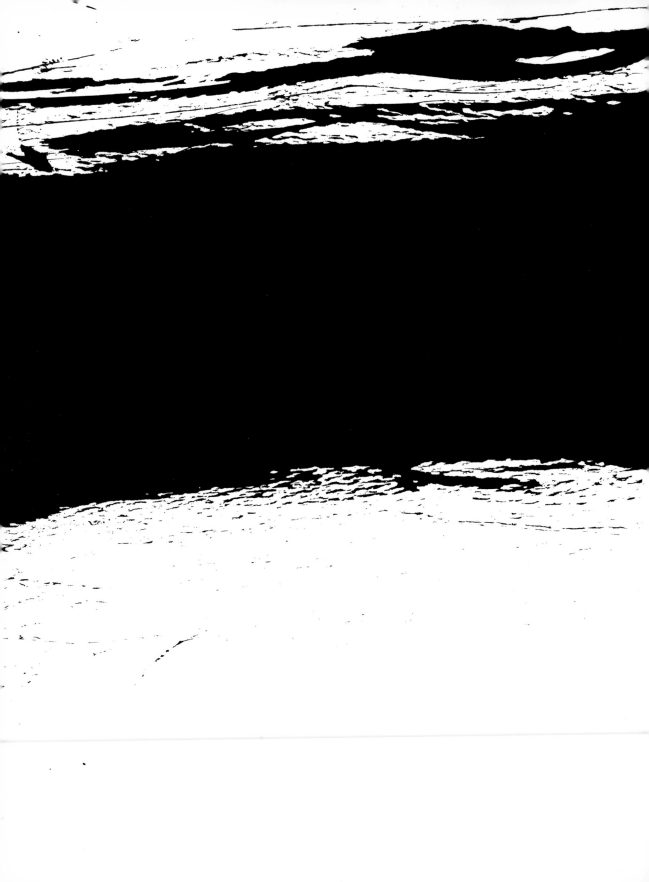

pen lines	brush lines
clear-cut	irregular
geometric	flexible
mechanical	organic
one-directional	multi-directional
repeatable	unique
analyzable	complex
predetermined	spontaneous
obvious	ambiguous
rational	mysterious
dualistic	all-inclusive
perfect	whole

When you are stuck with the pen paradigm, you might as well look for the brush paradigm. And vice versa.

Breath

Breath is a bridge between body and mind. Probably because of this, the ancient Chinese thought that breath was everywhere. They perceived breath as an activity of the atmosphere and as a symbol of transpersonal force, essential in art.

When I was thirteen years old, living in the Japanese countryside, an old man invited me to study Aikido with him. Out of curiosity I joined his small group. He would throw down several young men simultaneously and say, "You see? This is breath." I was totally confused by his statement as he didn't show any of his breath. Now forty years later I ask myself, "What was he doing by throwing people down? Does it have anything to do with the art I am doing now?"

I recently realized that the old man was collecting everyone's energies, positive and negative, unifying them in an extremely intense way, and moving his body just a little bit to throw down people who were much larger than himself. So the man, Morihei Uyeshiba, called the art he had created "Aikido" or "unifying-breath-way."

I think Morihei was not only a genius who transformed a way of fighting to one of love and harmony, but a great master of creative process. Over the years I have begun to see how my contact with him has influenced me. The style of one-stroke painting I am developing starts out with negative elements. Black ink drips all over the paper. The strands of the huge brush are loose. I quickly draw a line across the paper unifying all the movements and forms. The painting is finished and I stand looking down at it, just as Morihei looked at his disciples fallen down on the floor.

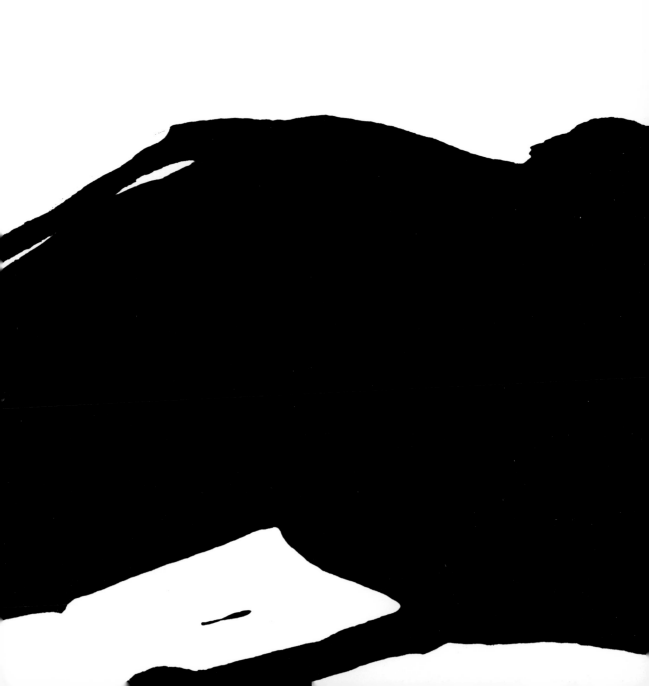

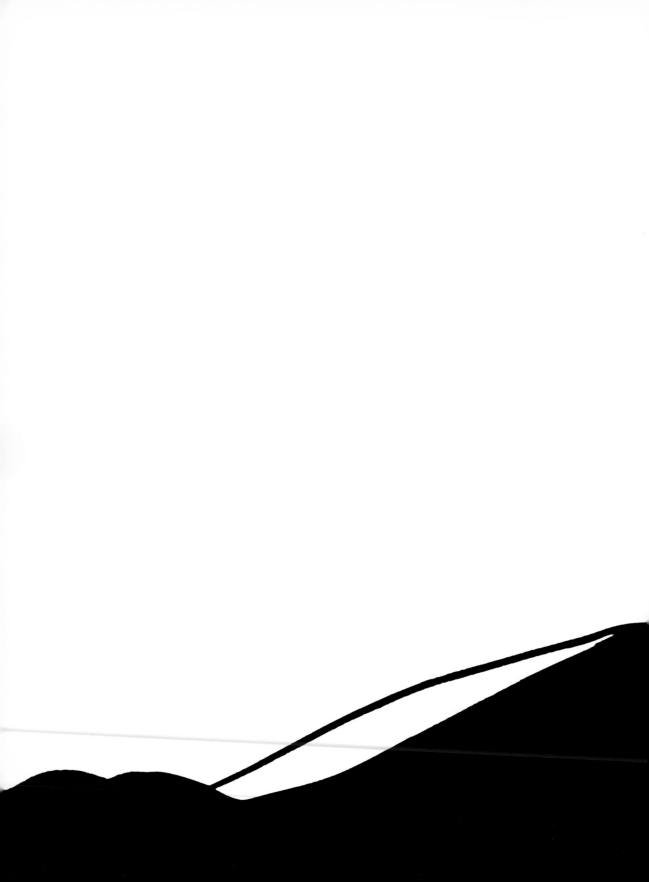

Breath is a conditioner of energy, mental and physical.

If each moment is our entire life, how dare we kill time? If each stroke is our entire breath, how dare we correct it?

Space

A painting without negative space is like music without silence. For music to have intensity, the silent part must be done well: a still moment can be the highlight of a performance.

Space is an extension of our inner force. This inner force is not entirely known. That is why artists struggle with or have fun with space.

Let the brush see it.

We cannot create space. When we try to make it, it is dead. But without our effort it does not appear. When we let it come, it is alive.

Extremely fast is extremely slow.

What is obvious is most difficult to see.

We speak more when we are insecure. We go farther when we are out of gas.

We should be exhilarated when least inspired, as we can be most creative when we have nothing in hand, nothing in mind.

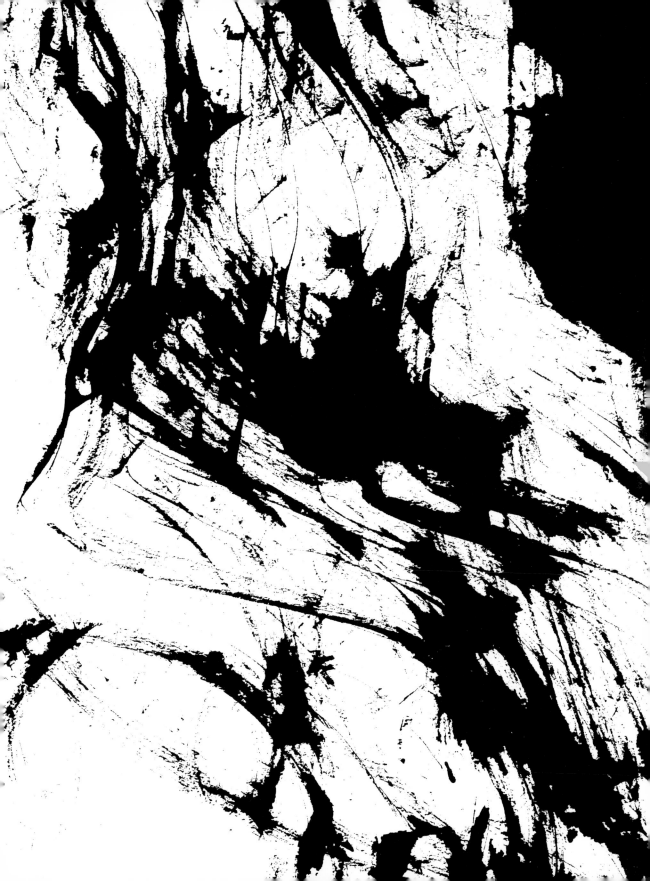

To go all the way from one side of the paper to the other takes too much time, so I have started no-stroke painting: You swing the brush just once in the air without touching the paper. An air brush.

Space is vast in any case. The question is whether the vastness is diminutive or enormous.

Mindfulness

I usually don't put a signature or seal on my paintings. This habit has led to a problem: I forget to sign my checks.

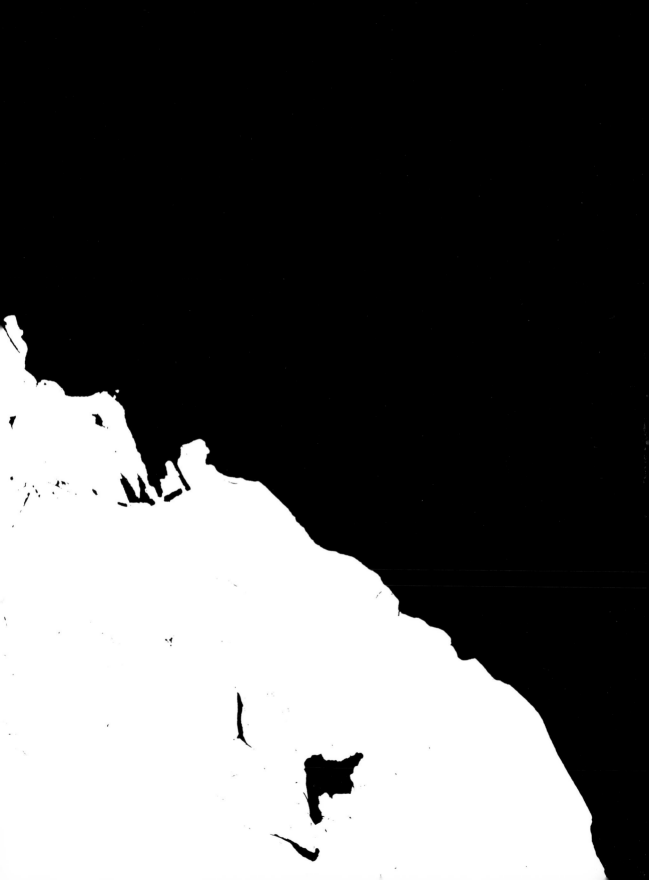

mindlessness
mindfulness

less mind
ness mind
full mind
single mind
empty mind
beyond mind
no mind
never mind

mindlessfulness

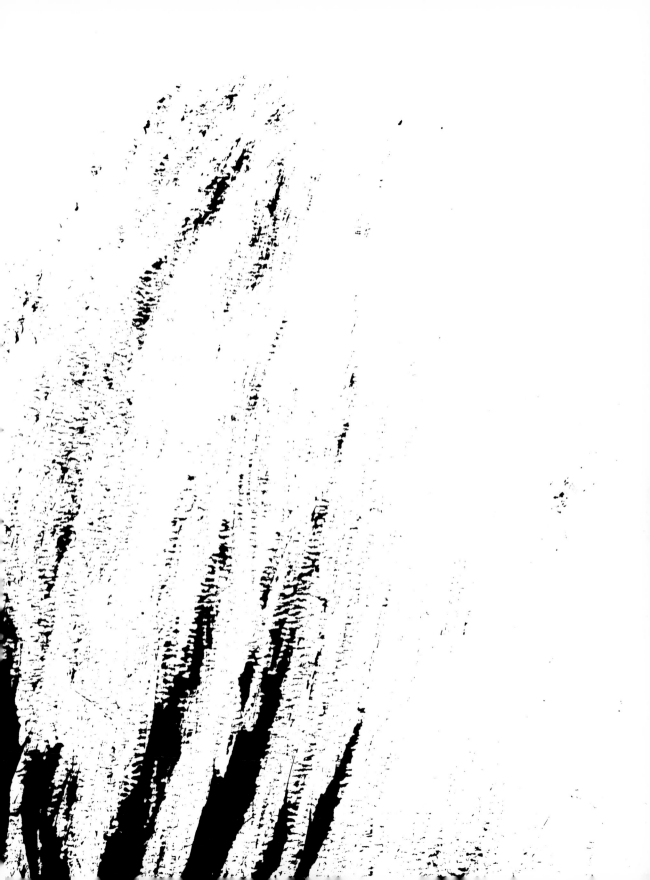

Meditation—healing from the epidemic of individualism.

The goal of meditation is not to have to do it. Is there any way to skip the process and get to the goal, since we are already not meditating at this moment?

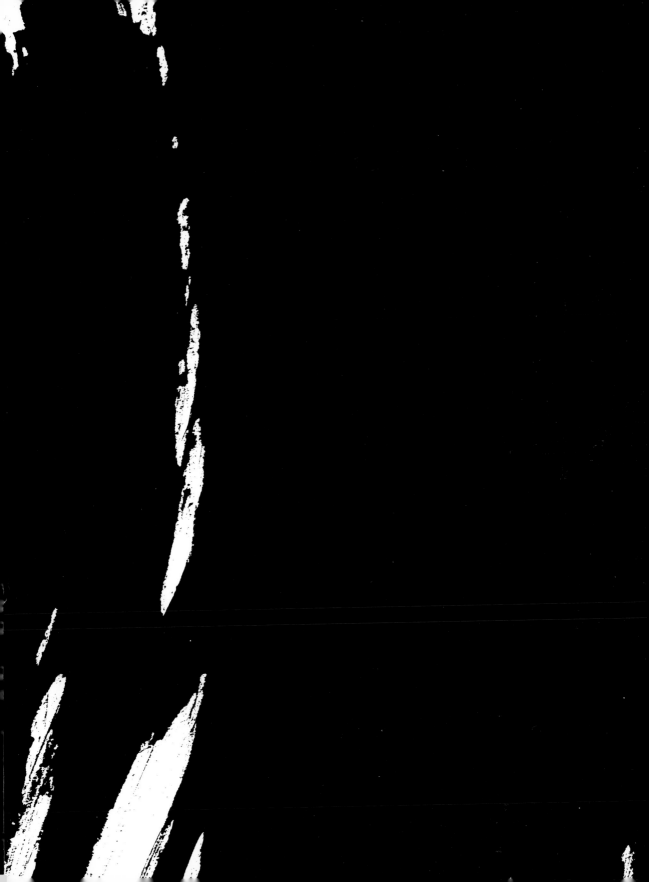

What is remarkable about Zen is to make your mind flexible and your legs numb. Most people specialize in the latter.

Insightful monks may say enlightenment can be experienced right now. Enlightened artists may say masterpieces are right here. Why are these things usually just a few inches away from me?

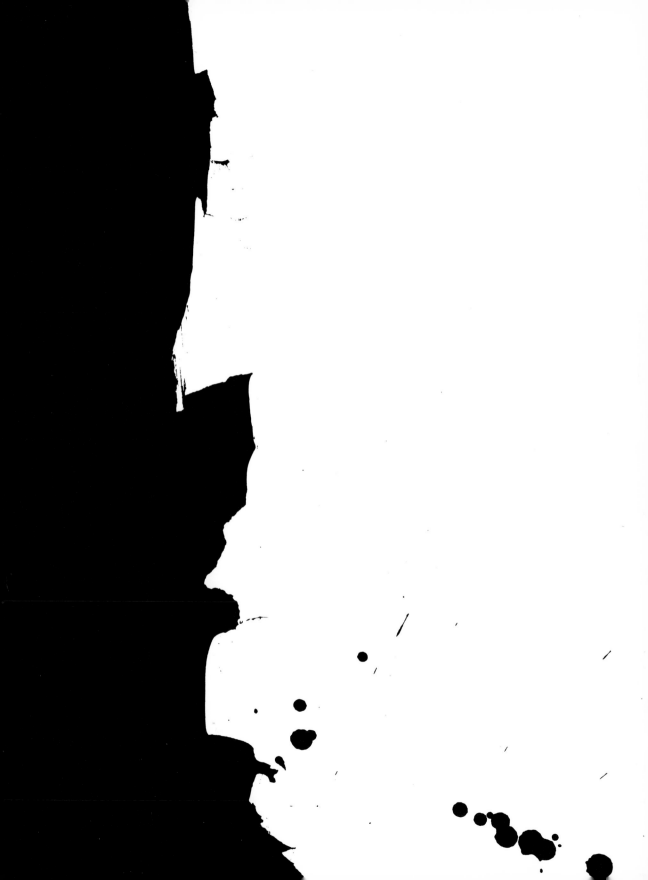

Brush Vision

Hush of wind
on a dark bamboo shaft
with moose-hair bristle.

Tails of horses
merged in one.
Wild elegance.

Glittery spread of
the peacock feather—
write me the ideogram for "shadow."

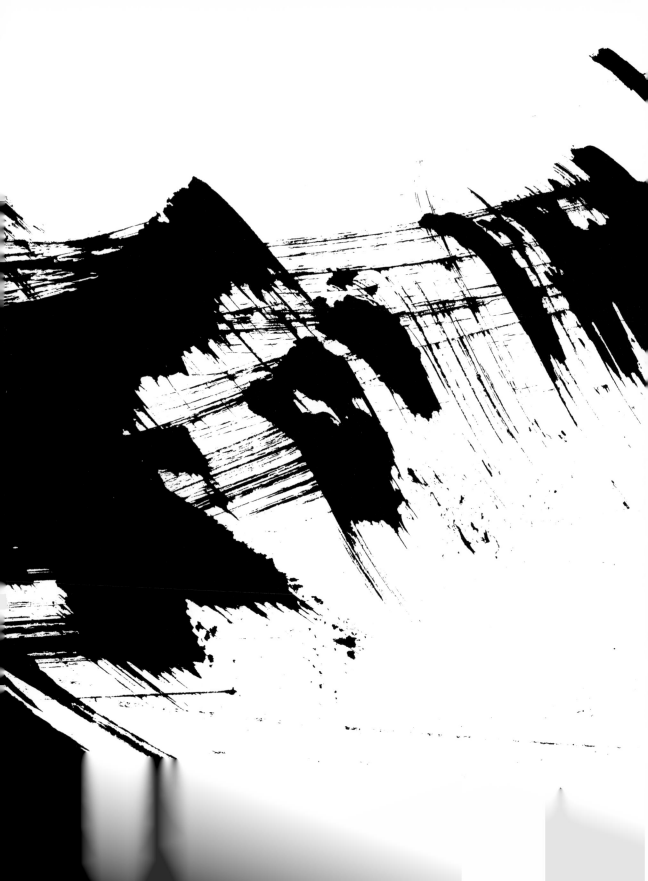

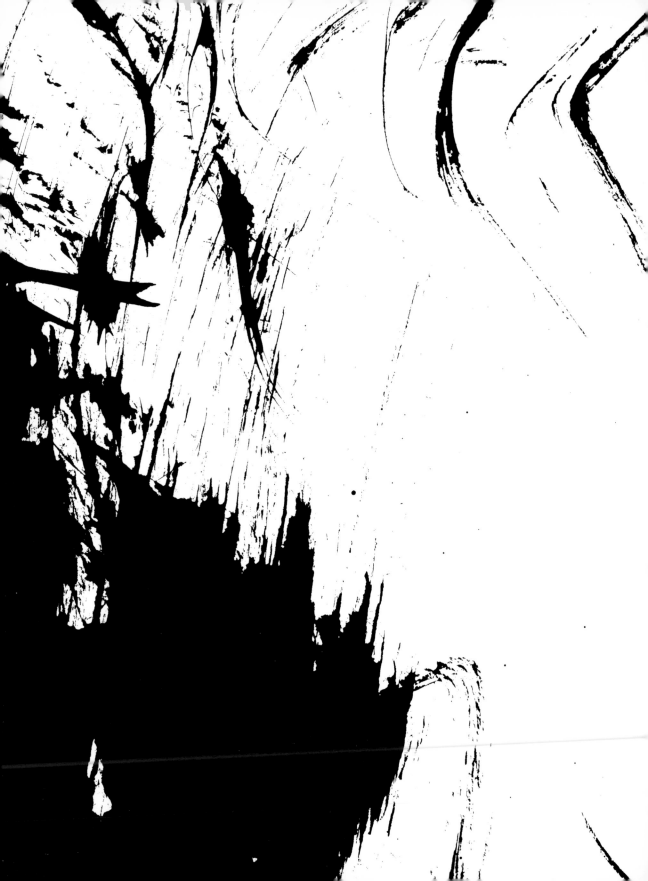

The brush loveliest and
most uncontrollable—
a bridal veil.

A ball of fluffiness.
Chicken down brush
snaking along, dipped in ink.

Definitely male smell.
Soft, compelling.
Goats' beard bristle.

Six whiskers of cat.
A wiggling line is drawn—
after a mouse?

Radical curves of
black swan feather.
Ink unseen.

The brush wouldn't move to sign
when a peasant in famine
had to sell his daughter.

Why did you send me
the brush made of
a black female bear's pubic hair?

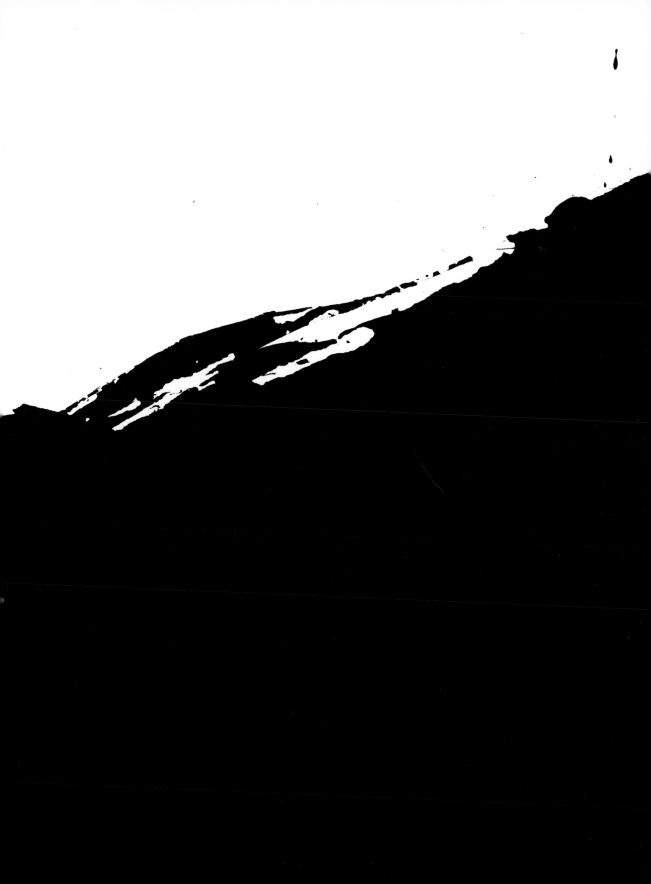

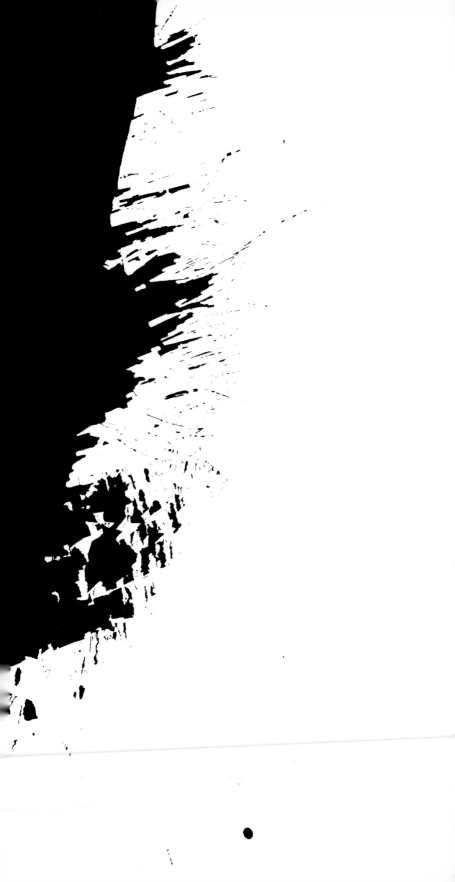

The sun in a bundle of sage
Ojai, California.
Five people sweep a line together.

One hundred lovely yogis
walking upside-down.
A fantasy brush.

A pair of brushes
piggy-back.
Elk's mane.

Lotus pistil—
a Silk Road brush.
Its traces wind into the desert.

Mountains in waters
emerge from the brush
in your heart.

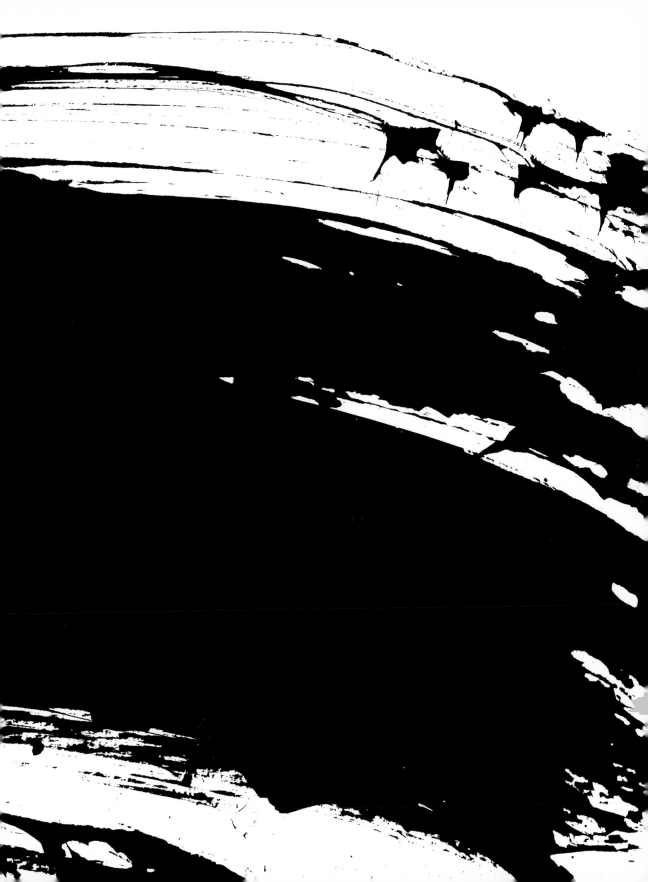

Immediacy

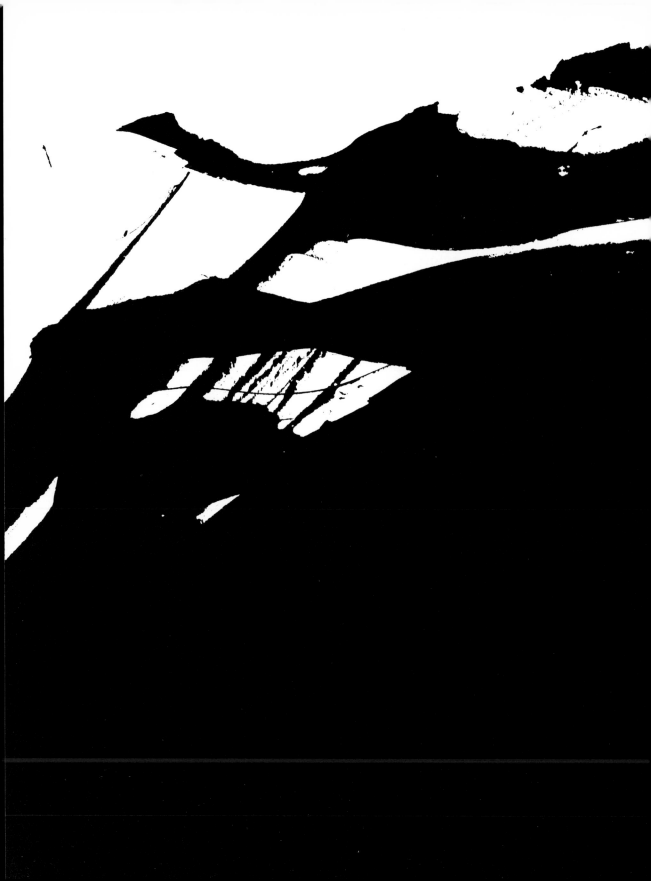

If a journey is a departure from where we usually are, a few minutes may be enough for us to go away and come back.

Immediacy is complete itself. How can we erase it?

There are no identical immediacies.

There is no suffering in immediacy, only in its delay.

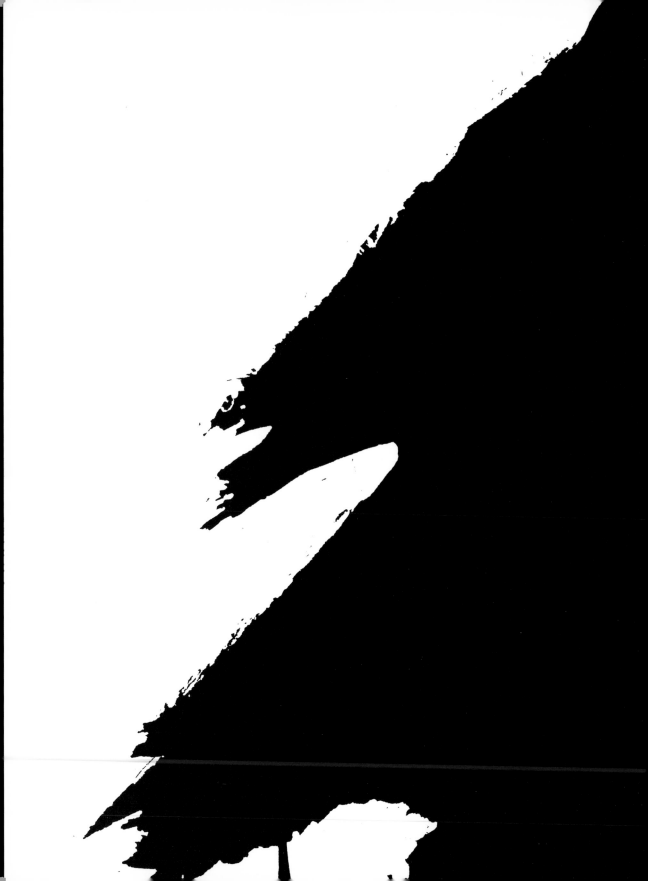

Failure now may be more enjoyable than success later.

A good teacher takes you somewhere else. An excellent teacher changes you where you are.

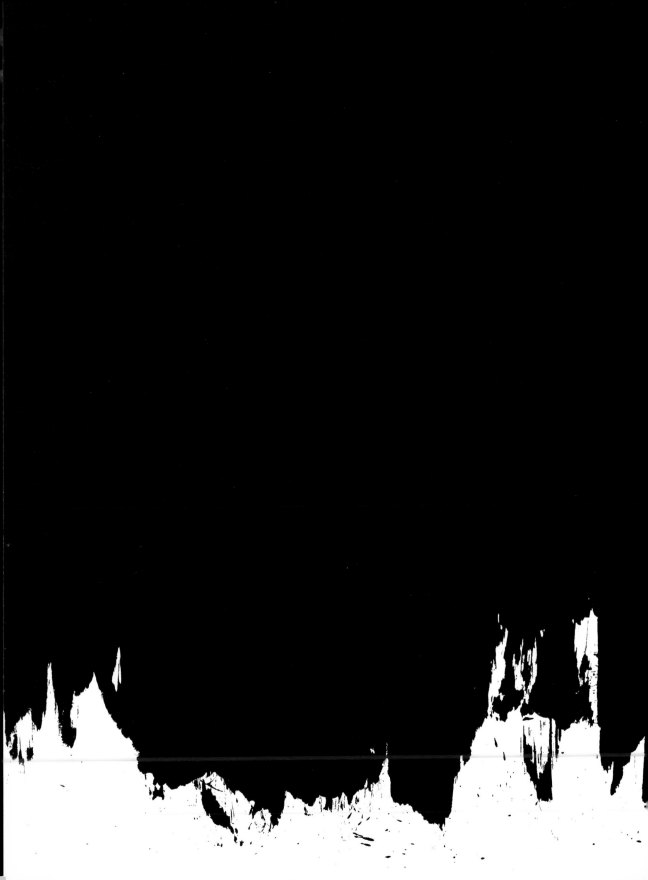

Skill is a hindrance. Looking good is a hindrance. Balance is a hindrance.

You work hard to get skill so that you can efface it.

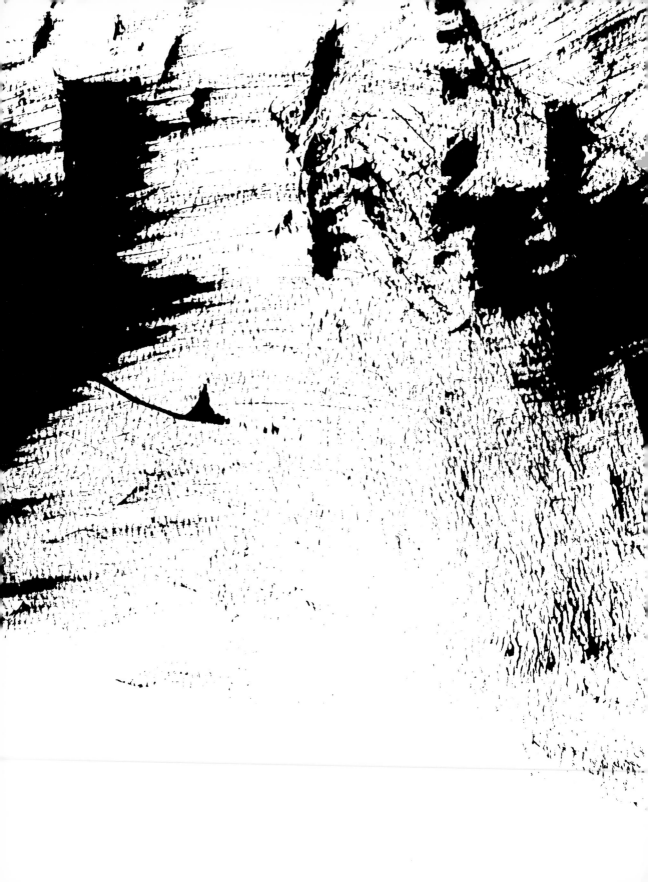

If I had to point to one statement that has affected my art most, it would be these words of Dogen, a thirteenth-century Japanese Zen master: "When you paint spring, do not paint willows, plums, peaches, or apricots—just paint spring." What is "spring"? How do we experience it directly?

The way, the process of spiritual practice, may be regarded as a winding path with ups and downs, its final point somewhere far beyond. It could also be seen as a continuous emerging of one ring after another. Each ring is the wholeness of the moment, inclusive of the entire means and end. A brush circle drawn by Zen masters may express this understanding. Each circle is different. Each circle is complete.

Serious Questions

Are you sure that cleaning the toilet is less creative than making pieces for a museum?

Would it be possible to find a frame that does not frame the picture?

Can nature be the frame of a picture?

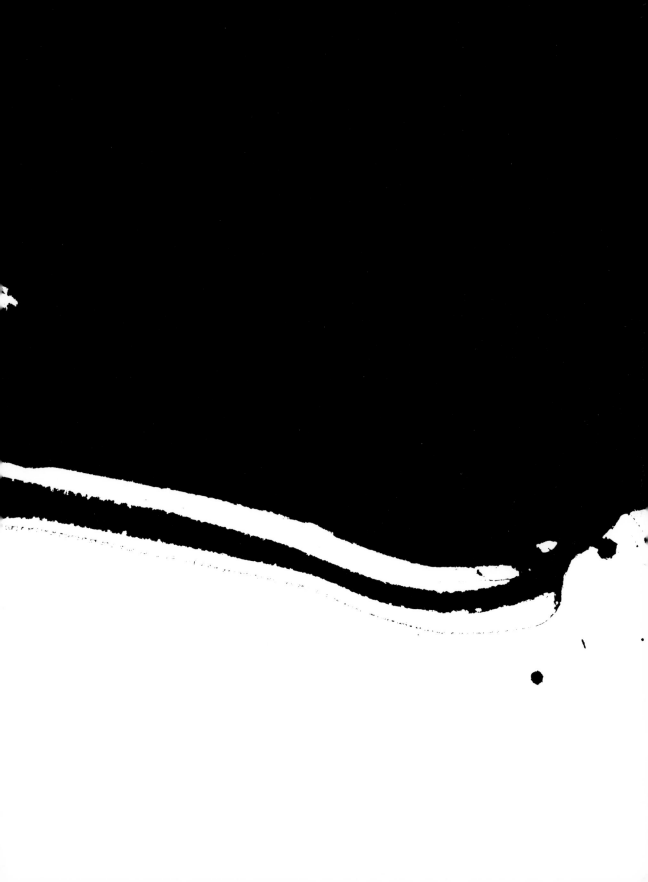

Can we see an invisible line that runs
through the visible?

Is there a way for the slenderest brush to be as
powerful as the largest one?

Aren't weeds, twigs, and rocks already brushes?

A mushroom brush? Don't you think it's a little too obvious?

In what way could we use a whole tree as a brush?

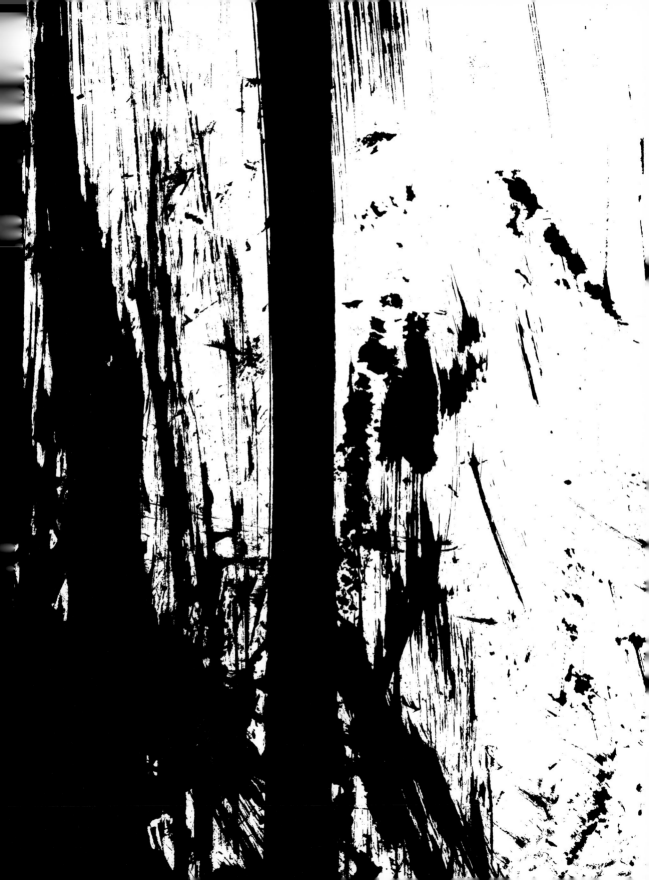

Does the brush paint, or does the ink? Or does the paper, the hand, the brain, the mind, the vision, or the person? Or does a painting paint?

Can five hundred paintings be created in one stroke?

One-line poem? Why not one-word poem?

If an essential teaching of Buddhism is to give up self, don't you think Buddhism should give up its own self? Can't Buddhism be most powerful when it's no longer Buddhism?

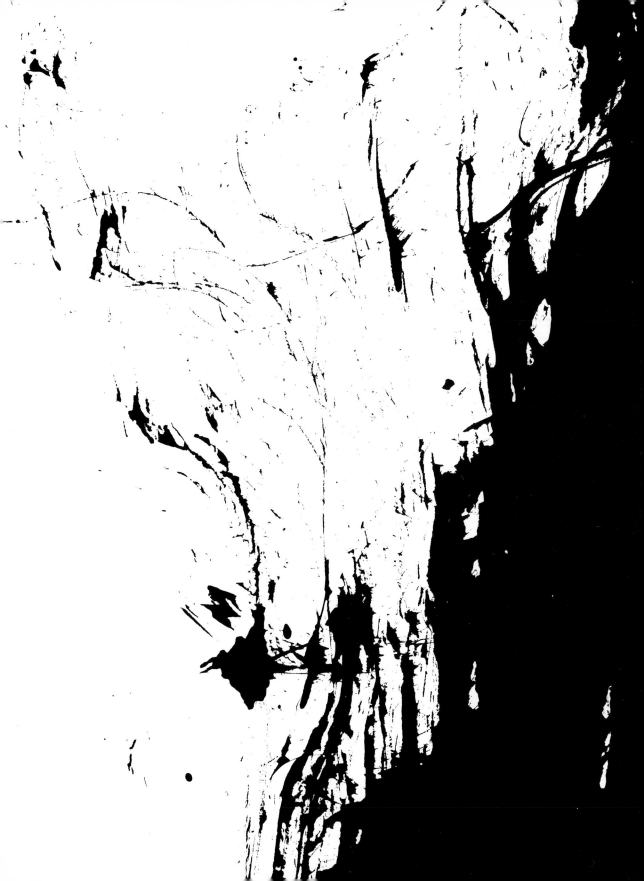

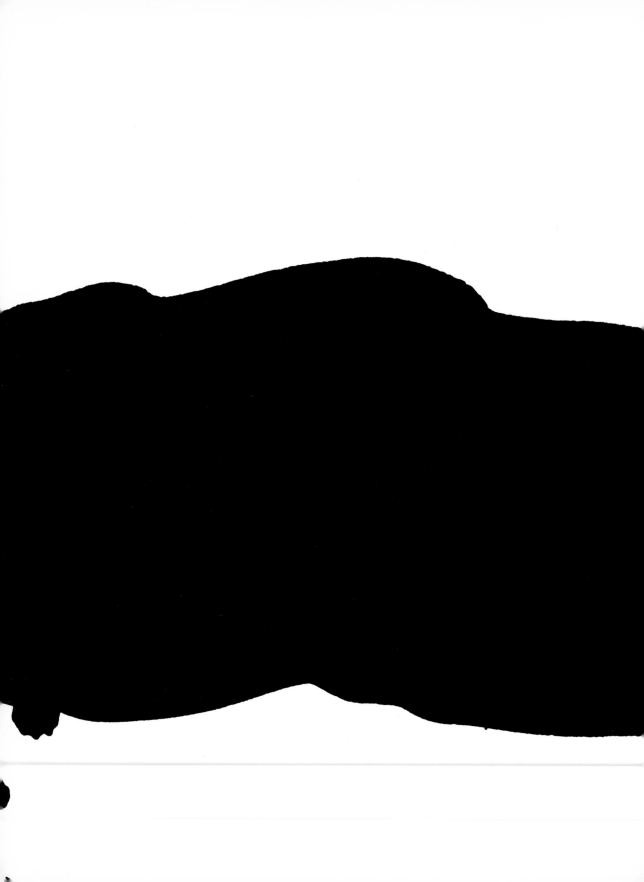

We usually evaluate creative process in terms of how much feeling or thinking was behind the work or how well the work was done. Isn't there any other way of appreciating the process? What if the standard of excellence was how fully present the artist was during the process?

Which is more artistic: to make an imaginative work of art, or to live an imaginative life?

If "aesthetics" means the study of "beautiful," is there an aesthetics that is the study of "beyond beautiful"?

In the standard European perspective, the viewer is large and all things are large in proportion to their closeness to the viewer, becoming smaller as they get farther away. The opposite perspective is seen in some ancient Japanese paintings, where the viewer is extremely small and things get larger as they are farther away. Instead of the self-inflated perspective with which we are familiar in modern society, don't we need the opposite perspective where the health of the Earth and the future of living things are infinitely larger than our individual need?

Reminders to Myself

If you are under control you lose the danger of glimpsing an unknown realm.

Some artists over a thousand years ago might have felt that they were completing the final stage in the evolution of art. It's funny that we still feel that way.

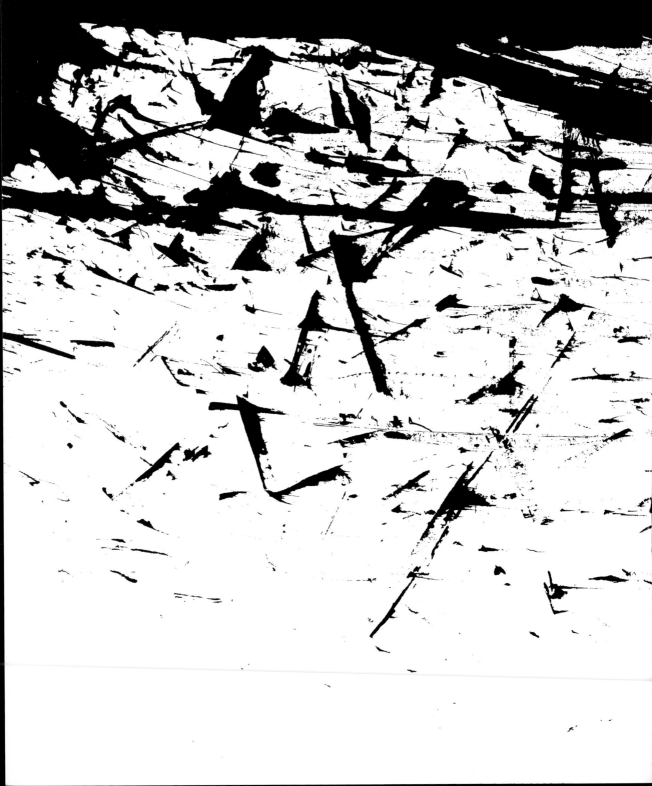

You cannot have accuracy without simplicity.

There is something calming about things you don't have complete control over. That's why a brush is more soothing than a ballpoint pen.

Artistic creativity relies on a continuous anxiety to create further. Does this anxiety tend to destroy the wholeness of the artist? Is it also the foundation for industrial development, the arms race, and high consumption, which are contributing to the destruction of the planet?

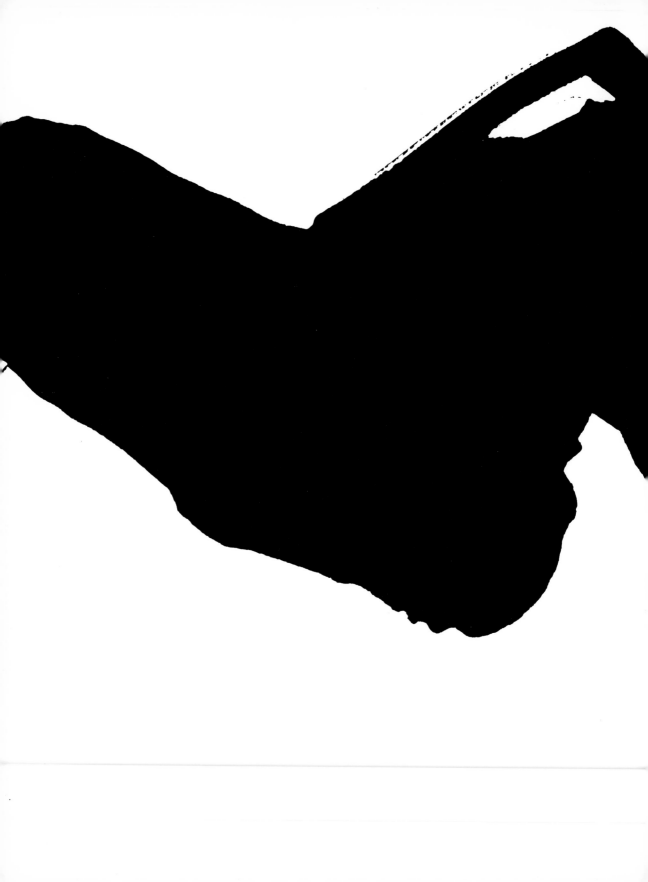

If we learn to enjoy waiting, we don't have to wait to enjoy. If enjoyment becomes immediate, most problems in life will go away. So will my ulcer.

If most of our creative thinking is done while waiting, it would be hard to find anything more exciting than a traffic jam or a six-hour delay at the airport.

What pleases our eyes is not dangerous enough.

If you have a poor hand, you cannot be a good sign painter. If you have a good hand, it may take extra effort to be an imaginative artist.

Refinement is my enemy.

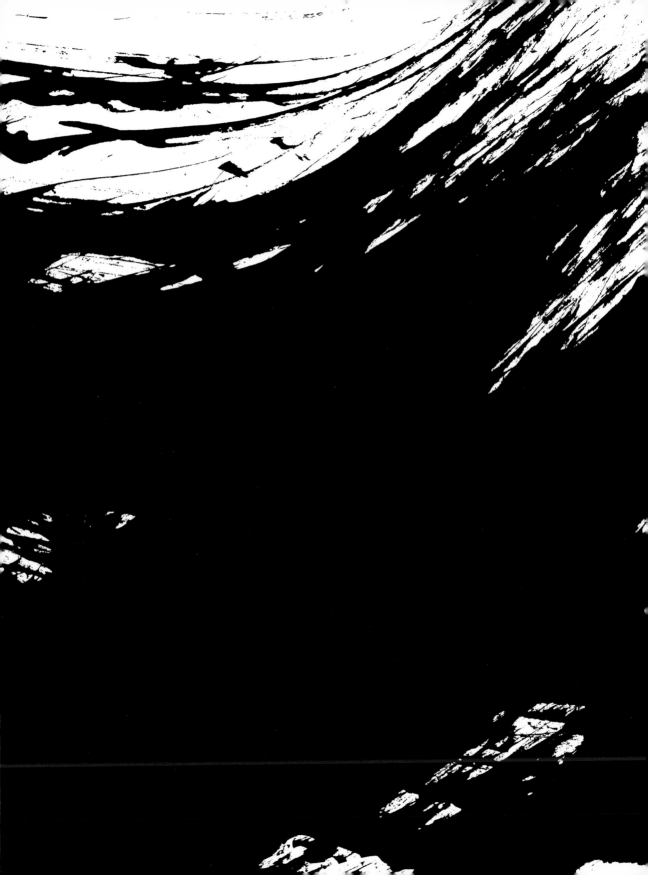

Landscape: what you see in yourself.
Self-portrait: how you want others to see you.
Figure: better to talk to than to draw.
Still life: something that moves too fast to capture.

If one line is too much, edit it down to seventeen.

Contradiction: a non-abstract element of logic.

When we talk about beautiful and ugly, usually we are talking about conventional aesthetic values. An artist is always playing with this, trying to get away from conventional standards and explore something unknown—something that may commonly be regarded as ugly or a failure.

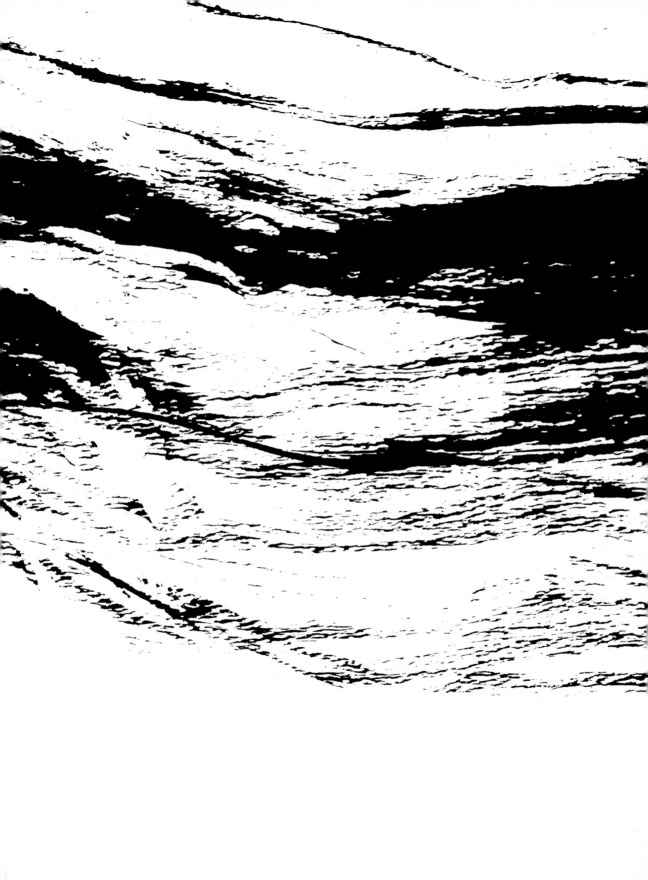

The quality of a work of art has nothing to do with how big it is, how much labor the artist has put into it, how expensive it is, how impressive it is, or how old or rare it is.

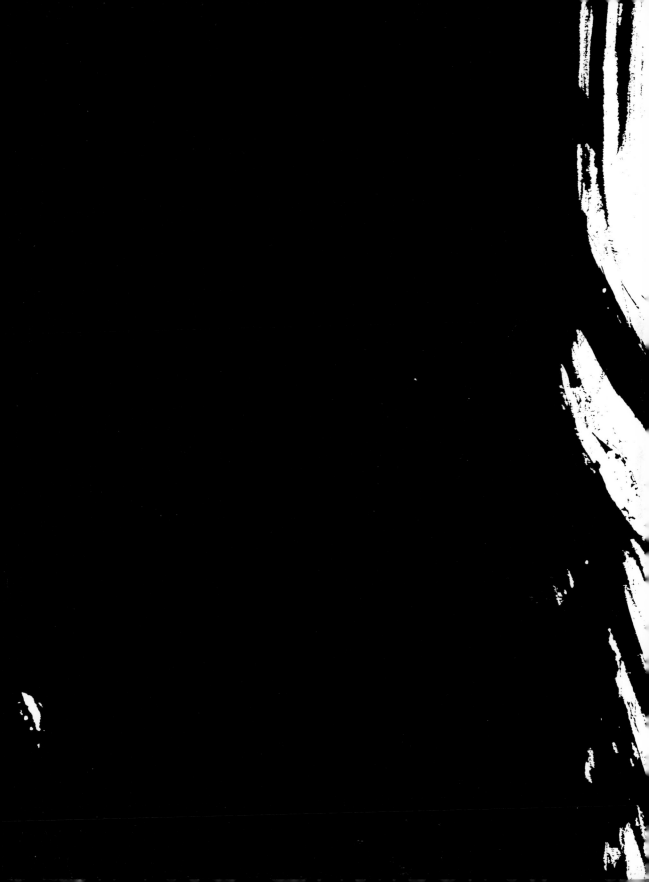

Aesthetics of Laziness

Attentiveness rather than efficiency.
Gentle flow rather than speed.

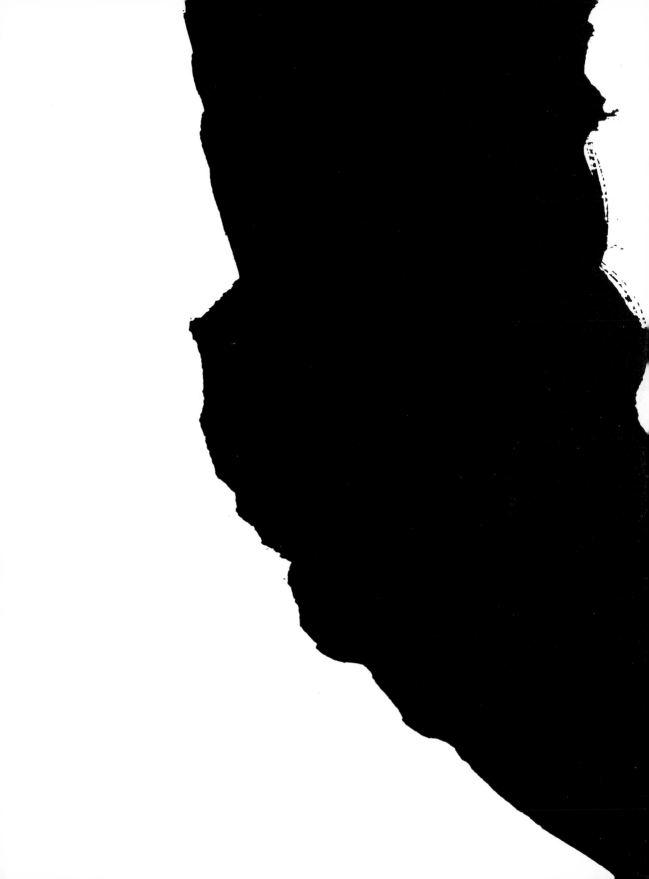

To have less control while painting and to permit something unpredictable to happen, one thing you can do is to paint without looking.

You need to concentrate if you want to do well. But if you are interested in not doing well, concentration gets in your way. Relaxation may be more helpful.

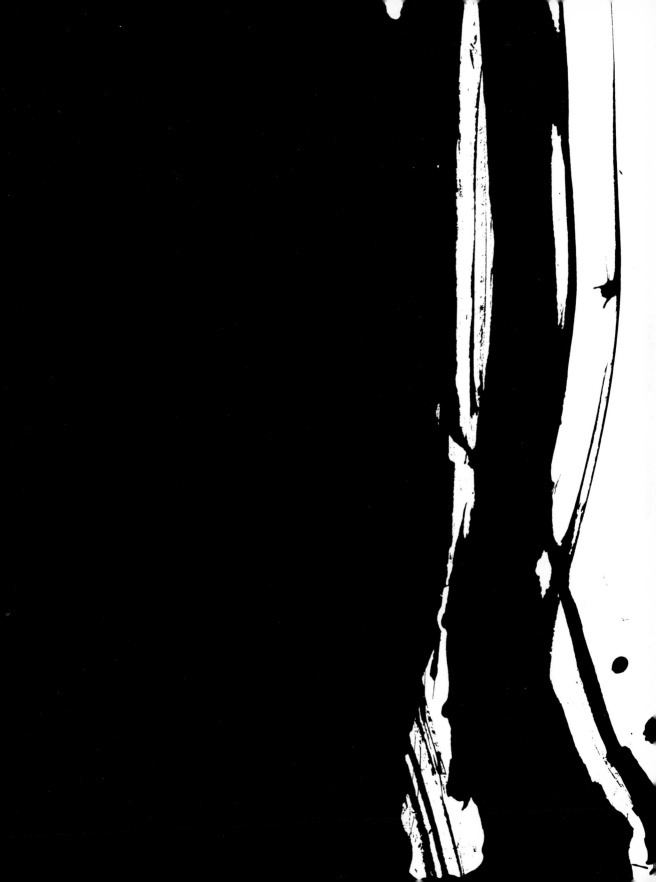

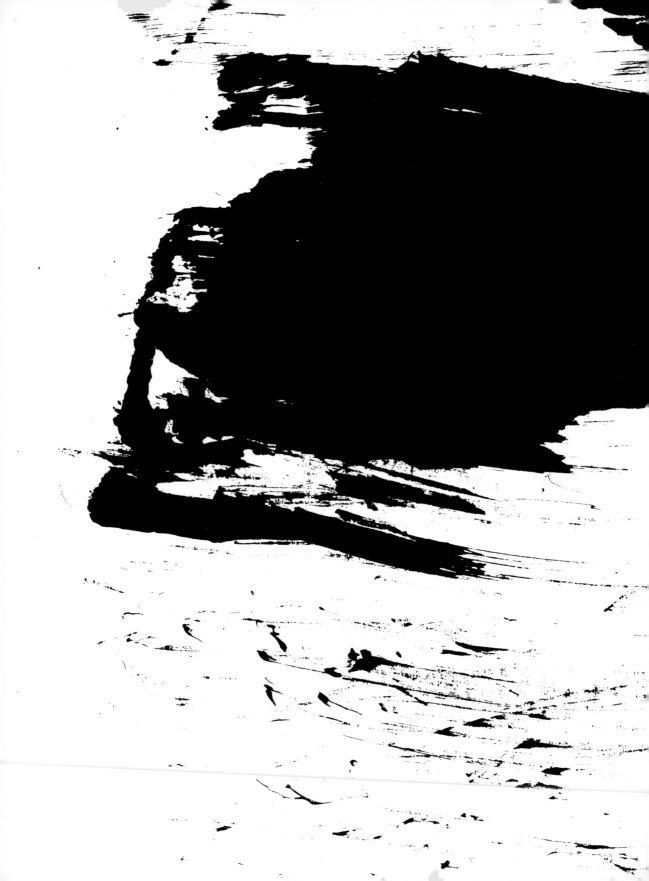

As soon as you accept the accidental effects, they are no longer accidents. They are necessity—the part of yourself that you could not expect or design beforehand. Thus the realm of your creativity grows wider.

Less judgment, less trying, less improvement, less regret.

There's no need to imagine before you paint. Painting brings forth imagination.

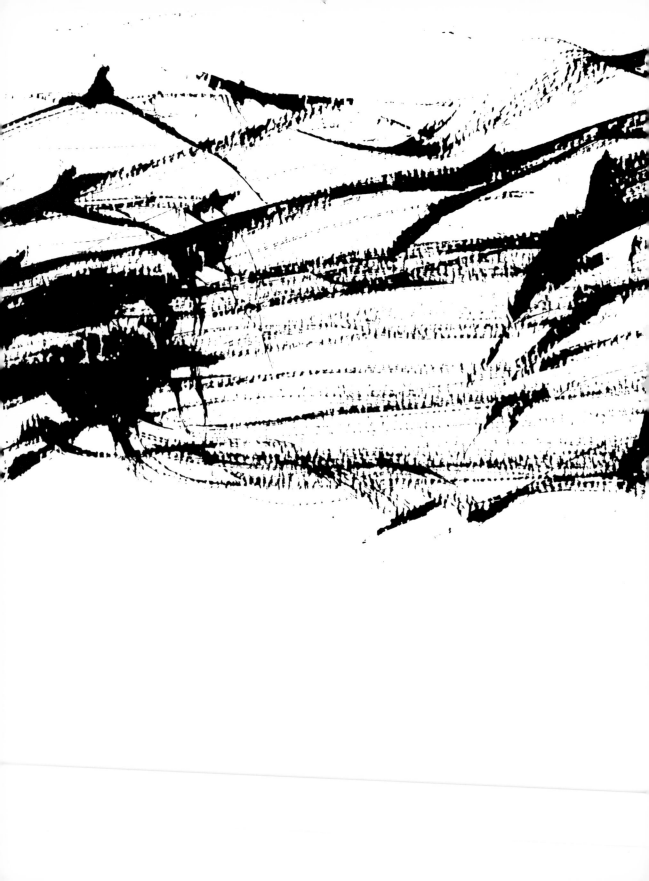

An unexpected power often comes when we are warming up, creating something that is not final. One way not to miss it is to regard the first practice piece as the final piece.

Why am I still a one-stroke painter? I am too lazy to do the second stroke.

If doing artwork is too relaxing, you may need something to make you tense. Try swimming.

To be thoroughly lazy is a tough job, but somebody has to do it.
Industrious people build industry. Lazy people build civilization.

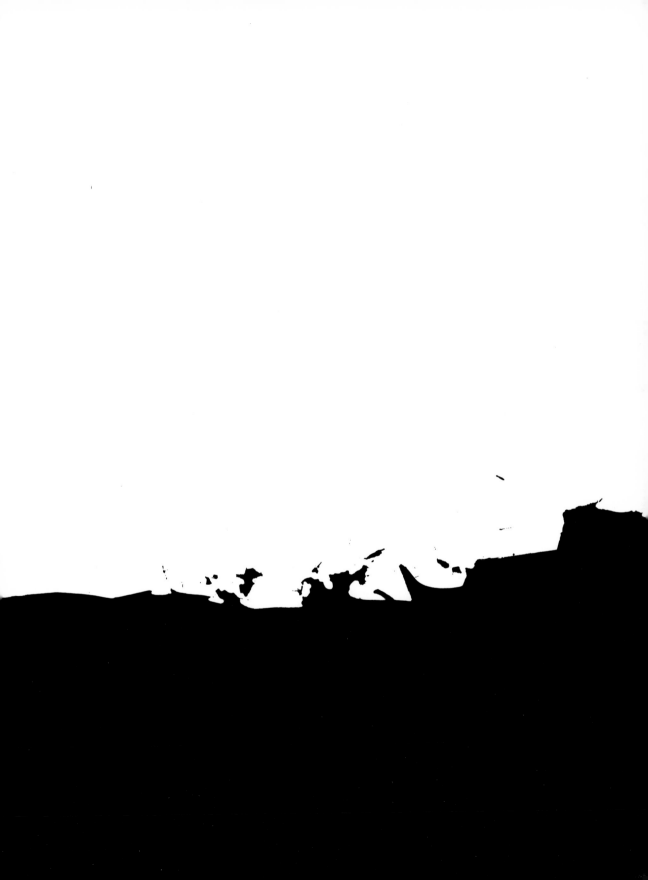

List of Illustrations

page	title	page	title
2	Mind 1	77	Mind 31
4	Mind 2	79	Mind 32
7	Mind 3	83	Mind 33
8	Mind 4	85	Mind 34
12	Mind 5	87	Mind 35
14	Mind 6	89	Mind 36
17	Mind 7	93	Mind 37
18	Mind 8	94	Mind 38
23	Mind 9	97	Mind 39
25	Mind 10	98	Mind 40
26	Mind 11	101	Mind 41
29	Mind 12	104	Mind 42
33	Mind 13	106	Mind 43
35	Mind 14	108	Mind 44
37	Mind 15	110	Mind 45
40	Mind 16	115	Mind 46
42	Mind 17	117	Mind 47
44	Mind 18	119	Mind 48
46	Mind 19	120	Mind 49
51	Mind 20	124	Mind 50
53	Mind 21	126	Mind 51
55	Mind 22	128	Mind 52
56	Mind 23	130	Mind 53
60	Mind 24	133	Mind 54
63	Mind 25	135	Mind 55
64	Mind 26	139	Mind 56
67	Mind 27	141	Mind 57
68	Mind 28	142	Mind 58
72	Mind 29	144	Mind 59
74	Mind 30	147	Mind 60

Kazuaki Tanahashi was born in Japan in 1933, where he studied painting and calligraphy. The first solo exhibition of his brushwork was held in Nagoya, Japan, in 1960. After exhibiting his work extensively in the United States between 1980 and 1987, Kaz created two travelling exhibitions: a series of paintings representing images of the end of the world is called "Stop the arms race or..." The other set of twenty paintings, "Surrender," all created in one stroke, was first exhibited in the Cathedral of St. John the Divine in New York City. He teaches brushwork for retreats at California School of Japanese Arts (Santa Rosa) and Zen Mountain Monastery (Mt. Tremper, New York). His publications include *Enku: Sculptor of a Hundred Thousand Buddhas* (Shambhala), *Penetrating Laughter: Hakuin's Zen and Art* (The Overlook Press), and *Moon in a Dewdrop: Writings of Zen Master Dogen* (North Point Press).

Parallax Press publishes books and tapes on universal responsibility and compassionate action—"making peace right in the moment we are alive." It is our hope that these books and tapes will help create a more peaceful world.

Recent titles include:

Being Peace by Thich Nhat Hanh
The Path of Compassion: Writings on Socially Engaged Buddhism by the Dalai
 Lama, Gary Snyder, Maha Ghosananda, Joanna Macy, and many others
Dharma Gaia: A Harvest of Essays in Buddhism & Ecology ed. by Allan Badiner
Happy Veggies a book of drawings by Mayumi Oda
The Heart of Understanding by Thich Nhat Hanh
The Moon Bamboo by Thich Nhat Hanh
World As Lover, World As Self by Joanna Macy
Present Moment, Wonderful Moment: Verses for Mindful Living by Nhat Hanh

For a copy of our free catalog, please write to:

Parallax Press
P.O. Box 7355
Berkeley, California 94707